A COMMON THREAD

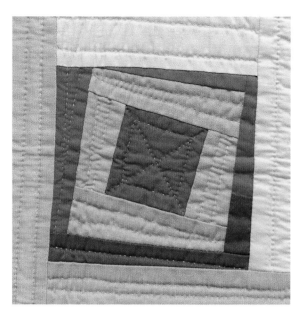

a common thread

a collection of quilts by **GWEN MARSTON**

Martingale
Create with Confidence

A Common Thread: A Collection of Quilts by Gwen Marston
© 2016 by Gwen Marston

Martingale®
19021 120th Ave. NE, Ste. 102
Bothell, WA 98011-9511 USA
ShopMartingale.com

Printed in China
21 20 19 18 17 16 8 7 6 5 4 3 2 1

Library of Congress Cataloging-in-Publication Data
is available upon request.

ISBN: 978-1-60468-813-9

MISSION STATEMENT

We empower makers who use fabric and yarn
to make life more enjoyable.

CREDITS

**PUBLISHER AND
CHIEF VISIONARY OFFICER**
Jennifer Erbe Keltner

CONTENT DIRECTOR
Karen Costello Soltys

MANAGING EDITOR
Tina Cook

ACQUISITIONS EDITOR
Karen M. Burns

PRODUCTION MANAGER
Regina Girard

**COVER AND
INTERIOR DESIGNER**
Adrienne Smitke

PHOTOGRAPHER
Brent Kane

CONTENTS

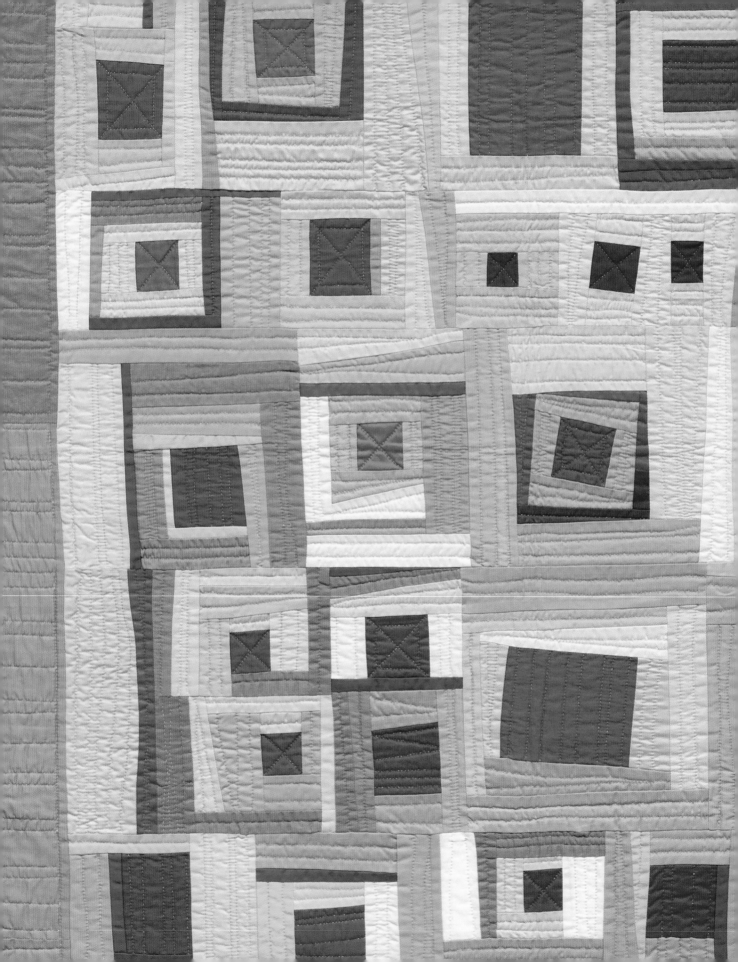

PREFACE

Working in the quilt-publishing industry for almost 25 years, I've seen hundreds, probably thousands, of beautiful quilts and have had the opportunity to work with many fascinating quilt designers and authors. But when the opportunity arose to work with Gwen Marston and create a coffee-table book that would be something of a retrospective of her designs and career as a quilting artist, I for one was thrilled. I have long admired Gwen's work, starting decades ago when she was known more for her appliqué quilts. Mind you, I had never appliquéd myself, but I loved the folk-art nature of her pieces—abundant flowers somehow standing tall in the smallest of vases, quilts with appliqué on just one side border, and bold colors I had never thought of using myself. I found her work to be unique and her sense of color joyful and uplifting. I was smitten from the start.

Whether you've been quilting as long as Gwen has, and you've seen her quilt art change over the years from appliqué and traditional patchwork to her liberated style, or you've come to know her more recently for her abstract and minimal pieces, I think you'll find that Gwen has continually grown and developed and challenged herself as an artist, all the while remaining true to her own sensibilities.

Meeting Gwen in person after years of enjoying her work was truly one of the highlights of my years in the quilting industry. Like her quilts, she's a bit unconventional and a whole lot of fun! But whether you have the opportunity to meet Gwen and take a class from her or you simply love her quilts and folk art, I'm sure you will enjoy this beautiful collection of quilts that Gwen has been making since the early 1970s. She curated the collection herself. As you pore over the pages of these magnificent quilts and study the lines, the color combinations, and the textures, remember that it is just a sampling (a large sampling, yet still only a portion) of Gwen's lifelong work as a quilt artist. It's a treasure that she has kept them all, and we are honored that she's willing to share them with all of us.

Karen Costello Soltys
CONTENT DIRECTOR, MARTINGALE

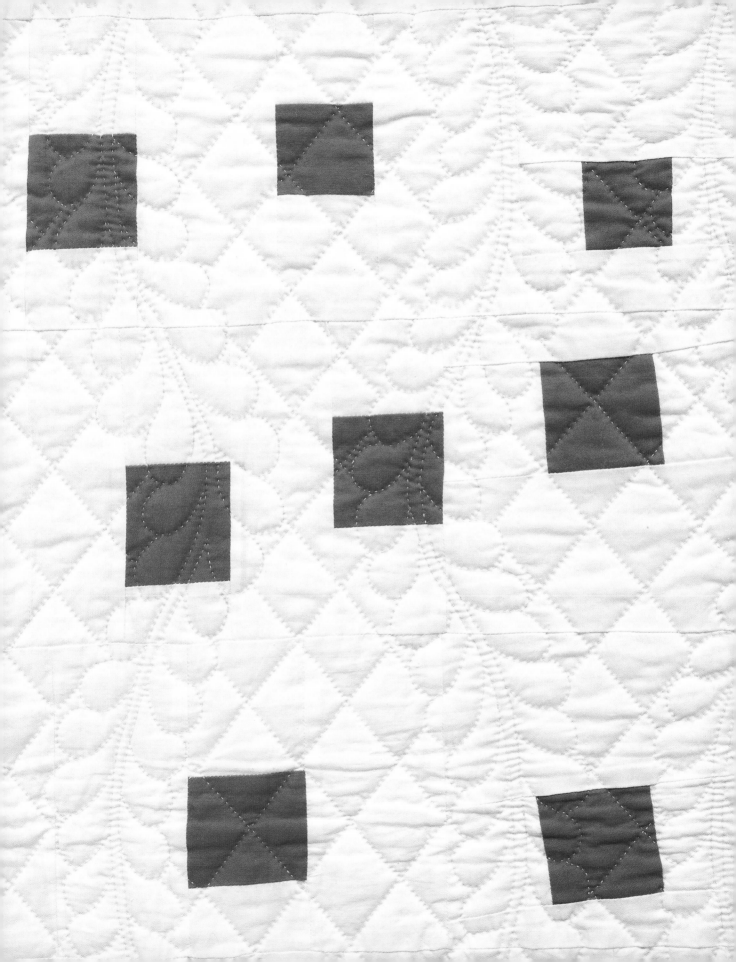

A NOTE FROM GWEN

Early in the 1970s, I saw an exhibit of fine antique quilts at my local art museum that spirited me on my way to becoming a quiltmaker. As a quilter I have always cherished participating in an art form that has primarily belonged to women. In a time when women had few rights, quiltmaking was one of the only ways they could express themselves, and they took marvelous advantage of that, as their quilts so richly confirm.

I began as most quilters do, by learning how to make quilts from traditional designs passed down through the generations. Often first teachers leave a big mark on us, and I had the good fortune to start out with great teachers. First, I spent a year in Oregon where a group of Mennonite women taught me to hand quilt and answered all my questions. They sent me off feeling that I could figure out what I needed to know and that the only tools I needed were right there in my sewing basket. I have always felt that these women gave me a gift for life.

The following year Mary Schafer, in her prime as a quiltmaker, took me under her wing—and my quilt education began in earnest. The knowledge and generosity these women shared with me very much colored how I see quilts and how I feel about quilts to this day.

Looking at antique quilts, I saw mounting evidence that many early quiltmakers were not following arbitrary rules nor were they using patterns. They obviously were figuring things out for themselves, which resulted in great diversity and innovation in their work. I also became aware that folk-art textiles the world around bore a common artistic feature: a certain amount of irregularity. What I found appealing in both the quilts and the folk-art textiles was that these pieces all clearly showed the hand of the maker. They were lively, had movement, and were imbued with elements of surprise, innovation, and originality. They were artful. I was hooked.

"To please herself only, the cat purrs." ~ *Irish proverb*

I figured out how to make appliqués by cutting shapes from folded fabric and placing them by eye to guarantee an ample dose of irregularity. I designed pieced quilts as I was constructing them, working intuitively and staying engaged throughout the process. I think working this way is the reason I'm just as excited today about making quilts as I was in the beginning.

~ *Gwen Marston*

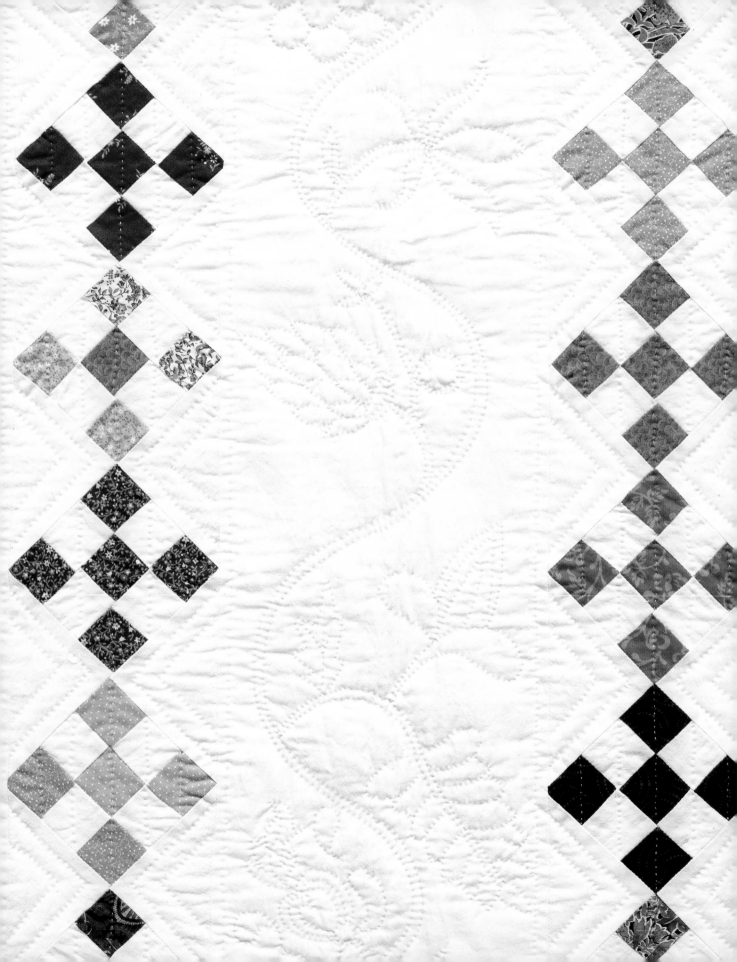

TRADITIONAL PATCHWORK

As many new quilters do, I began by making traditional quilts. My first mentors were Mennonite women, who taught me to hand quilt, and Mary Schafer, who shared her antique quilt collection with me. Their guidance helped me understand that old quilts had important stories to tell. I studied these quilts in detail to identify what made them so artful and then modeled my own work on what I had learned.

Although antique quilts were often based on a vocabulary of common designs such as the Nine Patch and Four Patch, quilters took great liberties in their interpretations, so there were rarely two alike. I was particularly drawn to these common designs known to most quiltmakers. They were simple enough to construct that everybody could make them, and they did, but the range of original interpretations within that simple framework was dazzling. Other characteristics I saw in antique quilts were unpredictability, spontaneity, and playfulness, all of which I find particularly appealing. Random color placement, pieced patches, color substitution, asymmetry, blocks turned different ways, no corner resolutions, and less concern about precision all combined to make these quilts unstudied, unpretentious, and more interesting, not to mention less stressful and more fun to make.

Over the years of studying antique quilts, I have seen a wealth of evidence that earlier quiltmakers were figuring things out for themselves. For me, that seemed like a good path to follow and has always been part of the fun of making a new quilt.

"I treasure being part of a traditional art form practiced mostly by women. Being connected to many generations of quilters has a strong appeal for me."

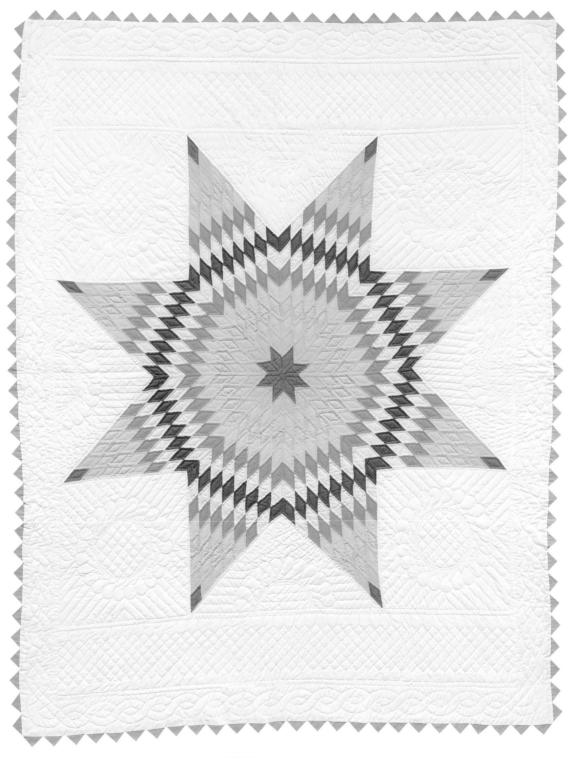

LONE STAR 68" x 85" | 1976

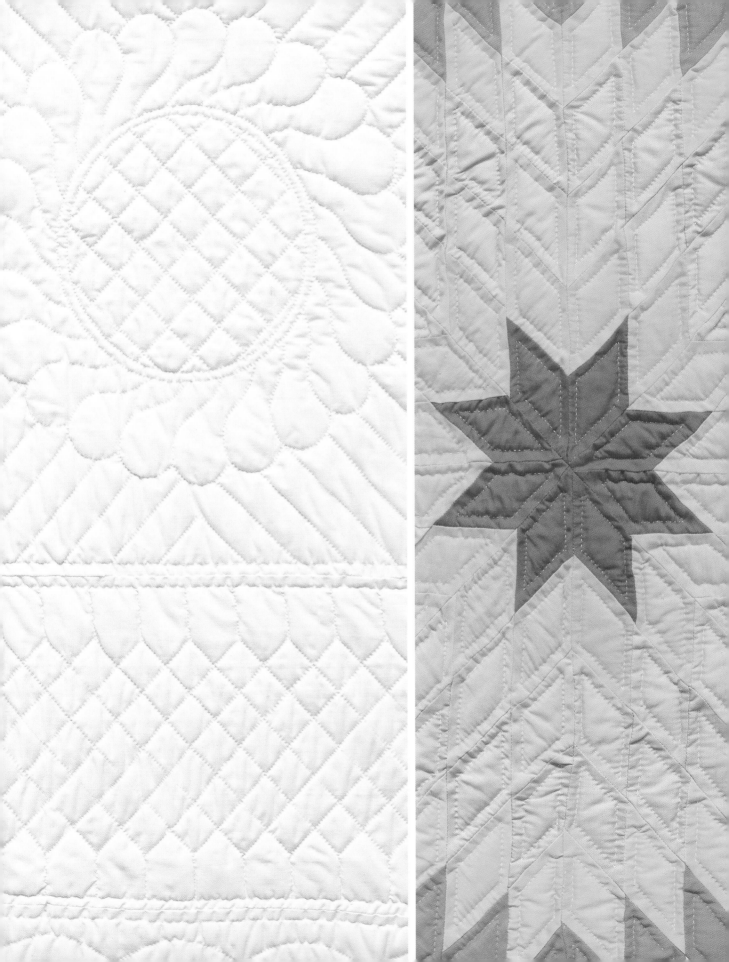

NINE PATCH IN BARS 80" x 84" | 1986

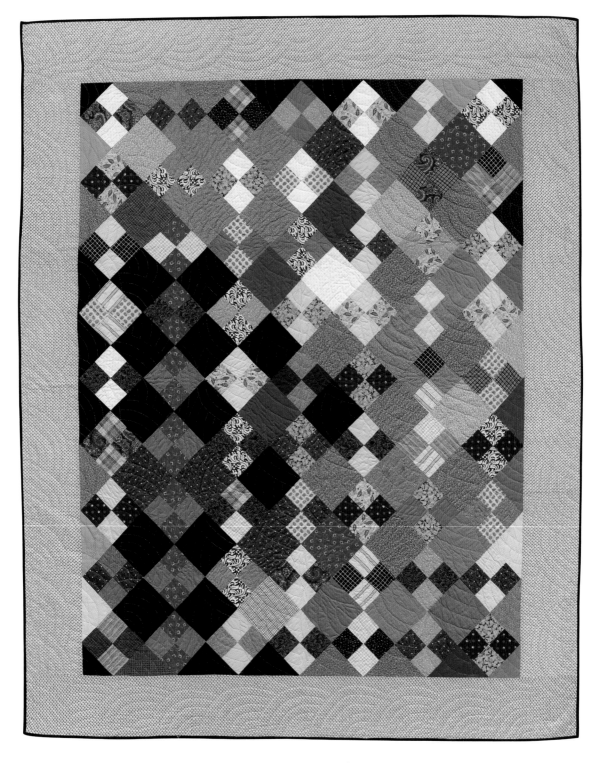

FOUR PATCH 62" x 72" | 1991

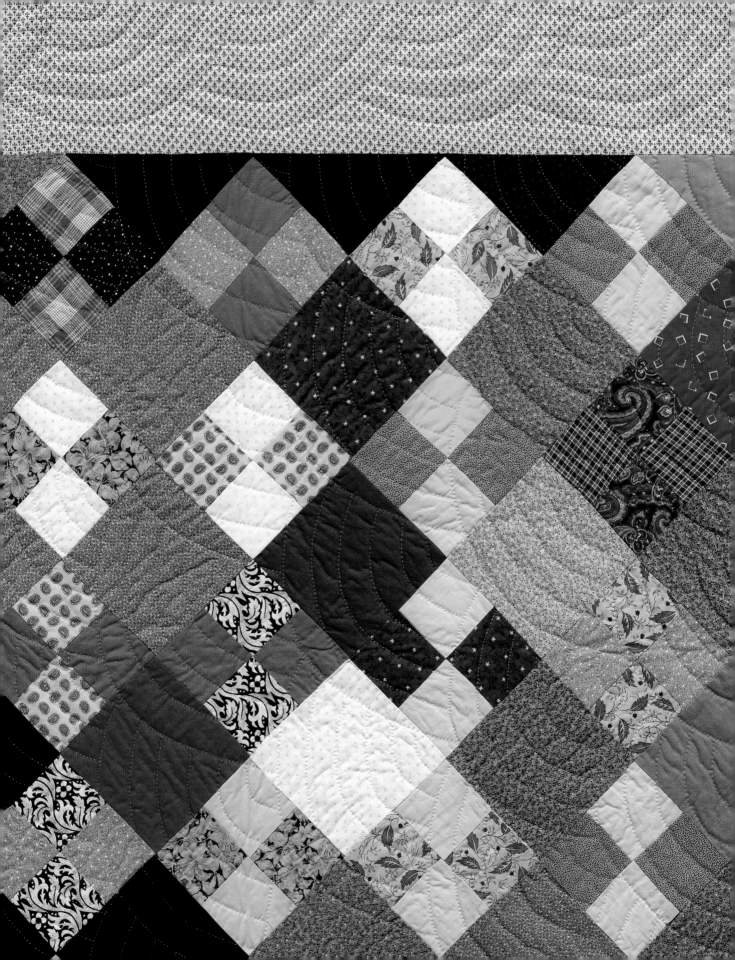

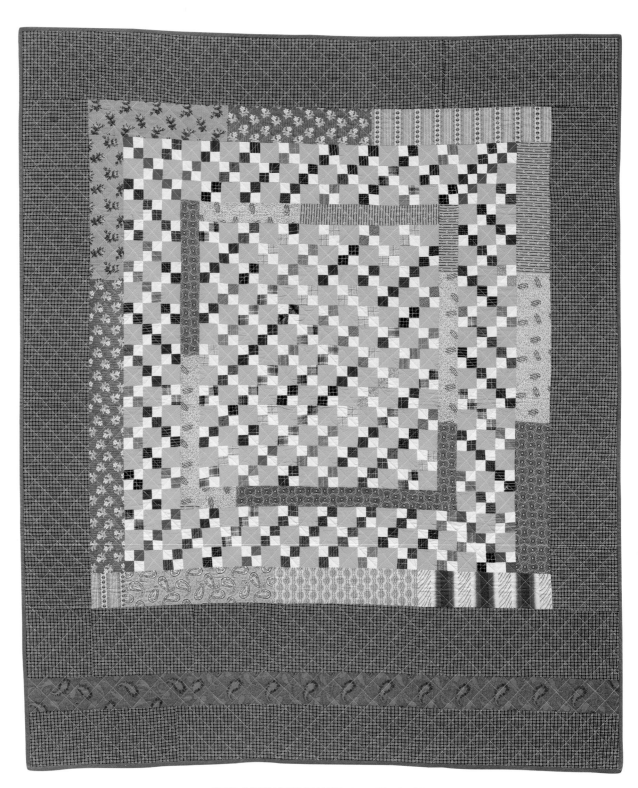

FOUR PATCH MEDALLION 61" x 72" | 1991

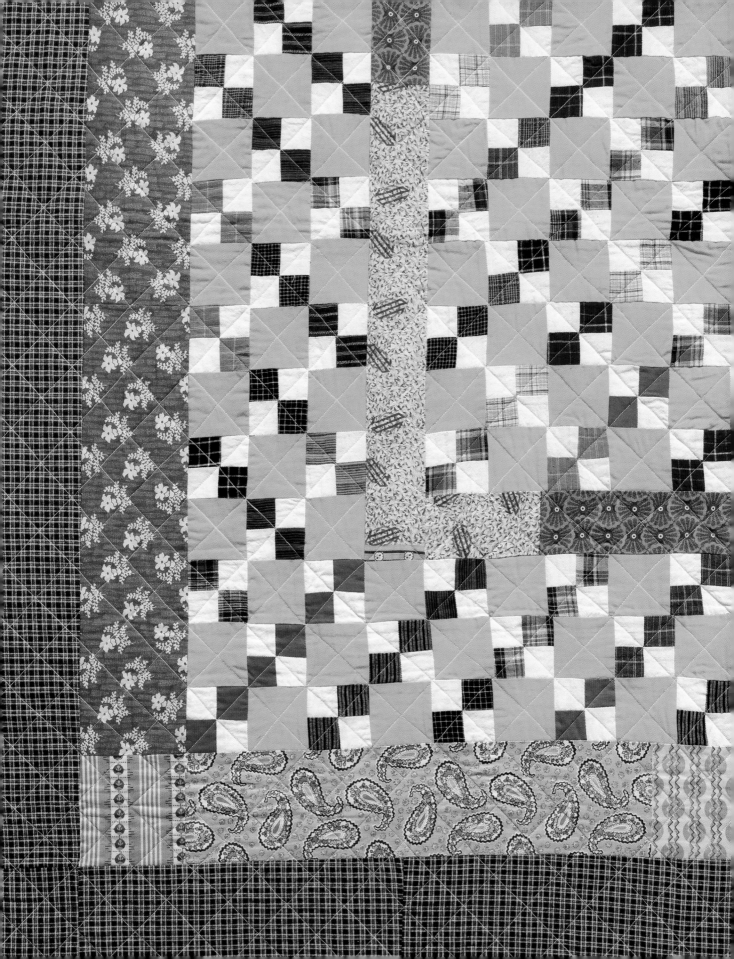

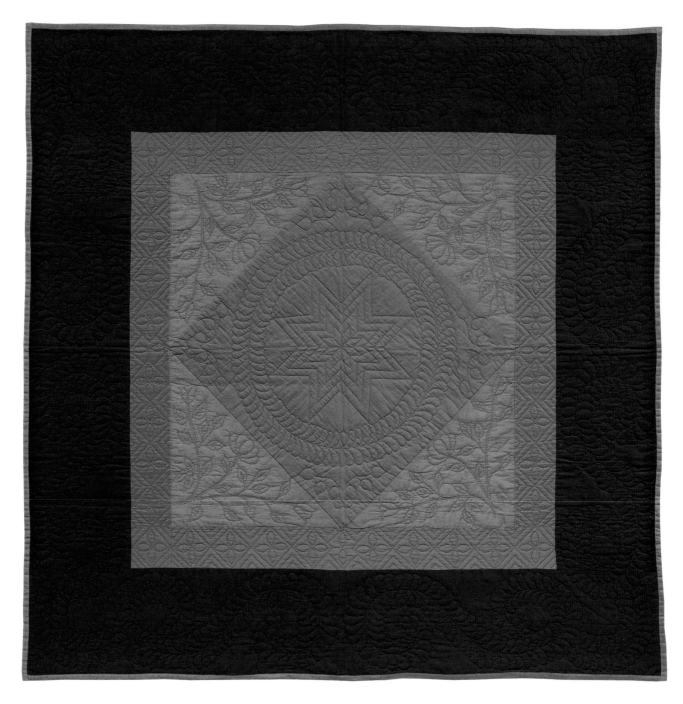

CENTER DIAMOND 72" x 72" | 1992

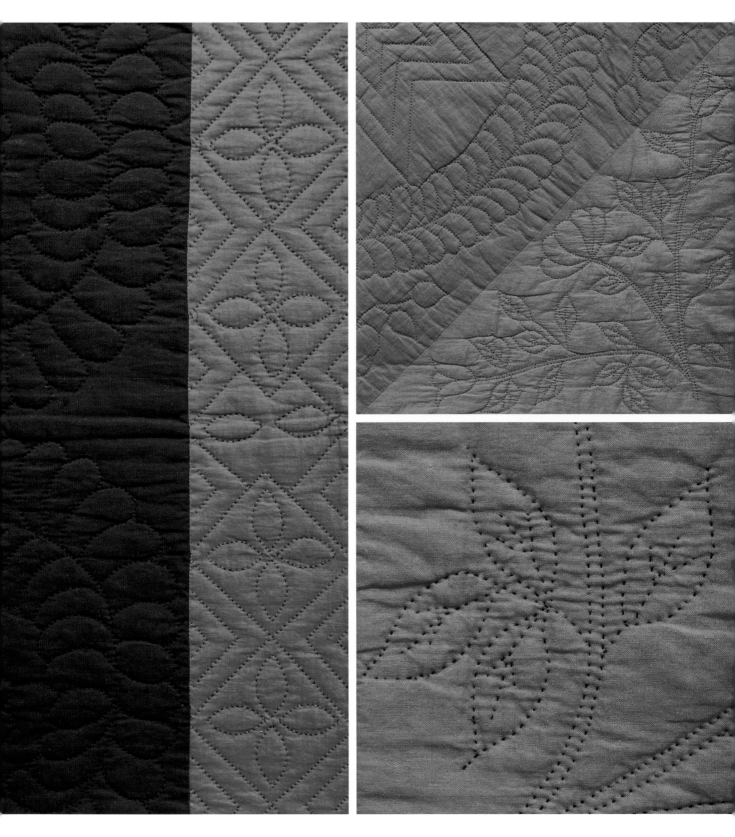

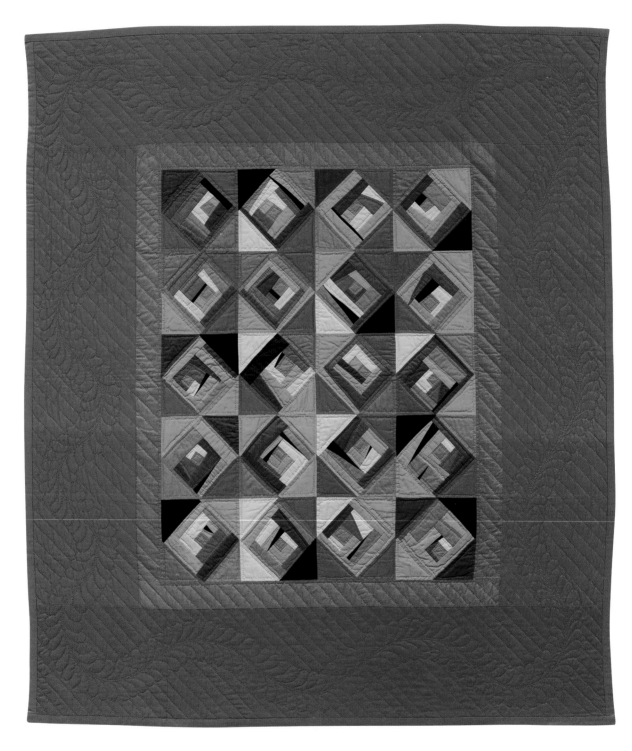

LOG CABIN ON POINT 56" x 64" | 1992

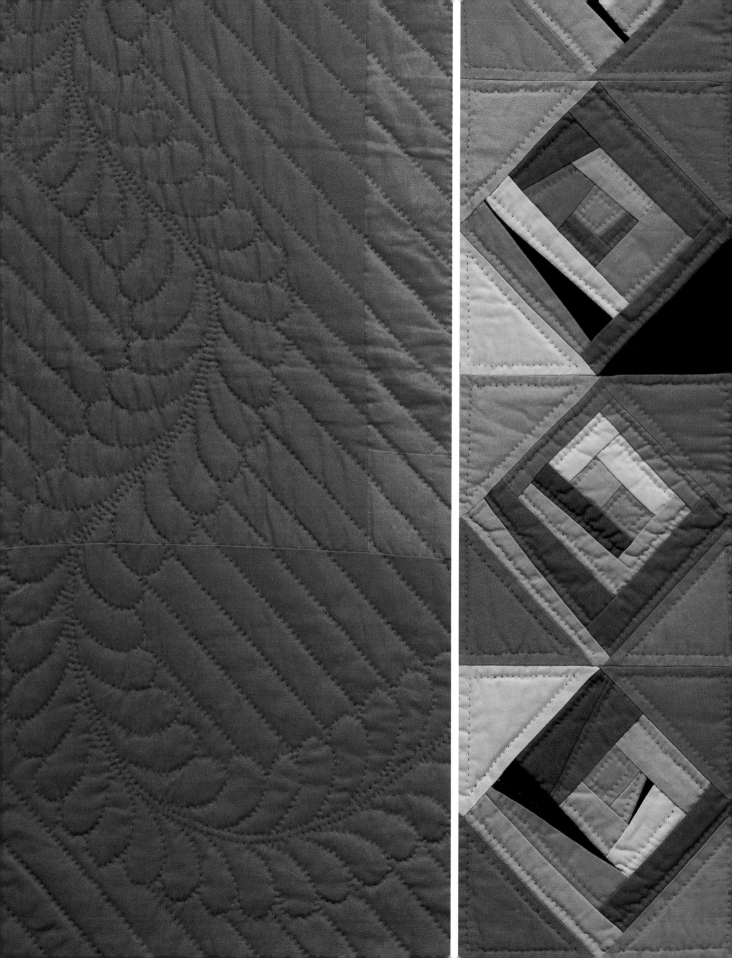

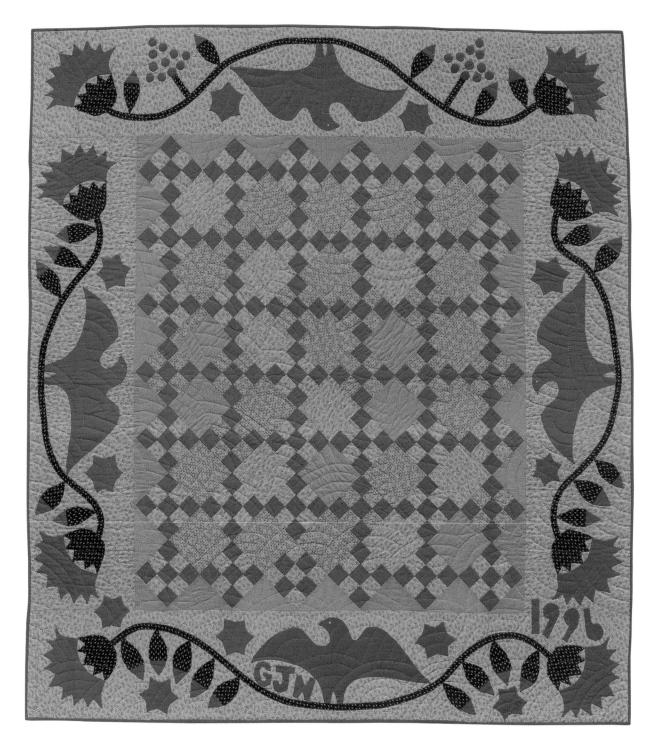

NINE PATCH AND RED-TAILED HAWKS 60" x 66" | 1996

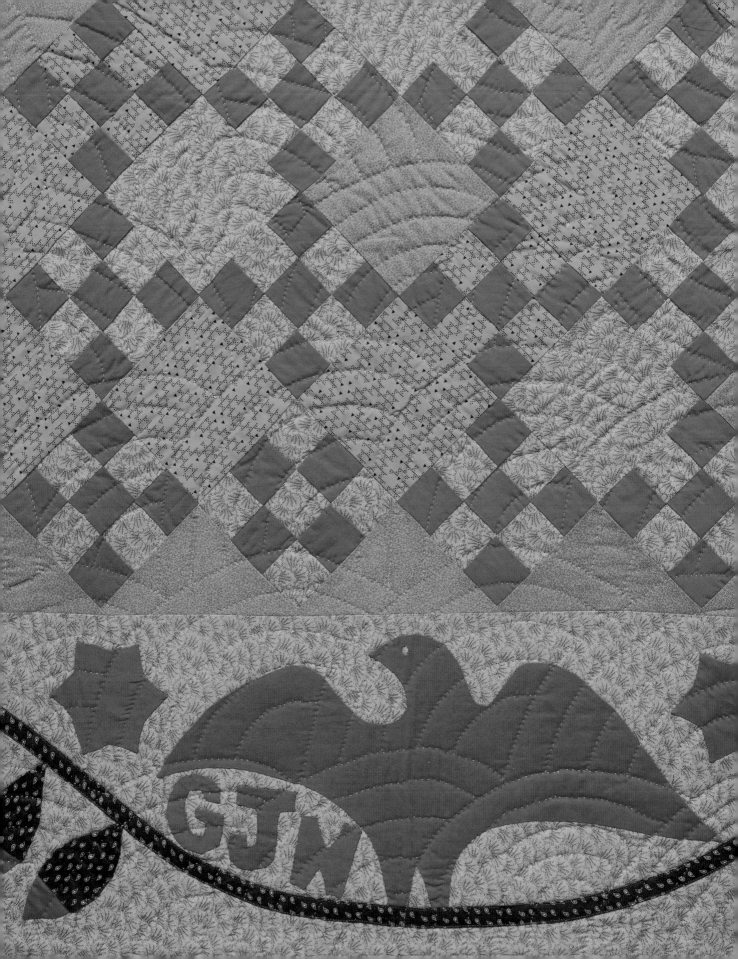

CHURN AND DASH WITH APPLIQUÉ BORDER 73" x 79" | 2000

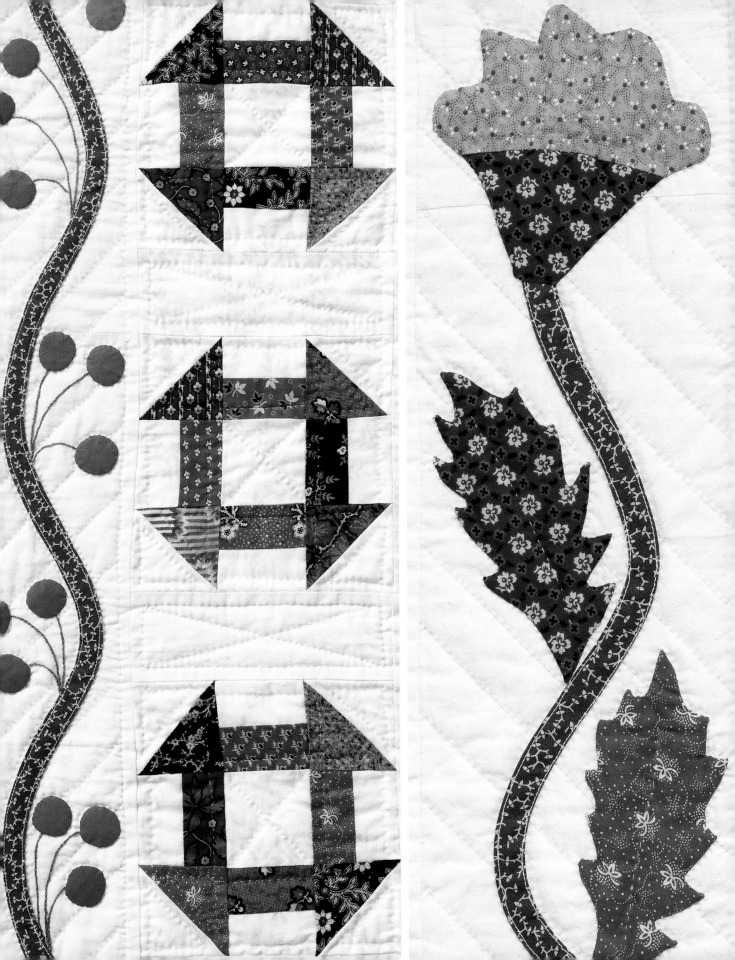

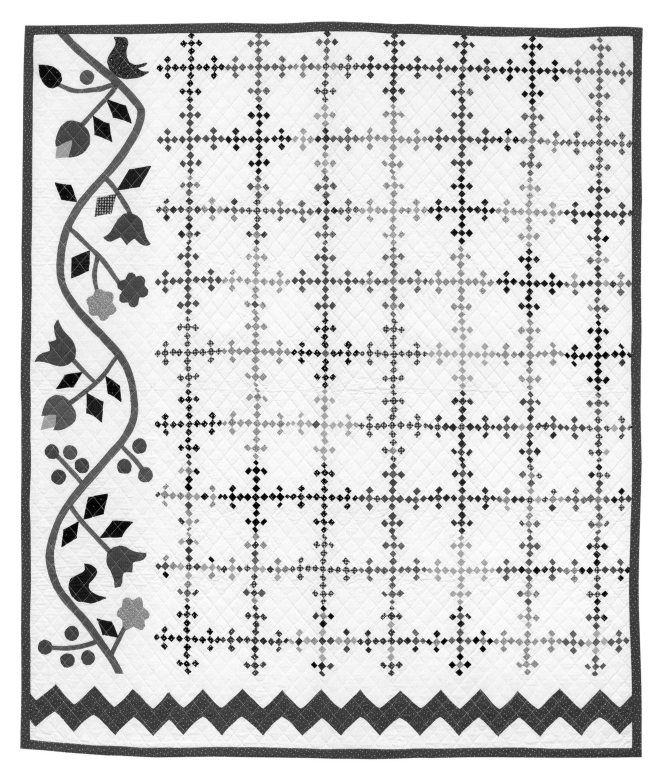

GWENNY'S LITTLE BITTY NINE PATCH 58" x 66" | 2002

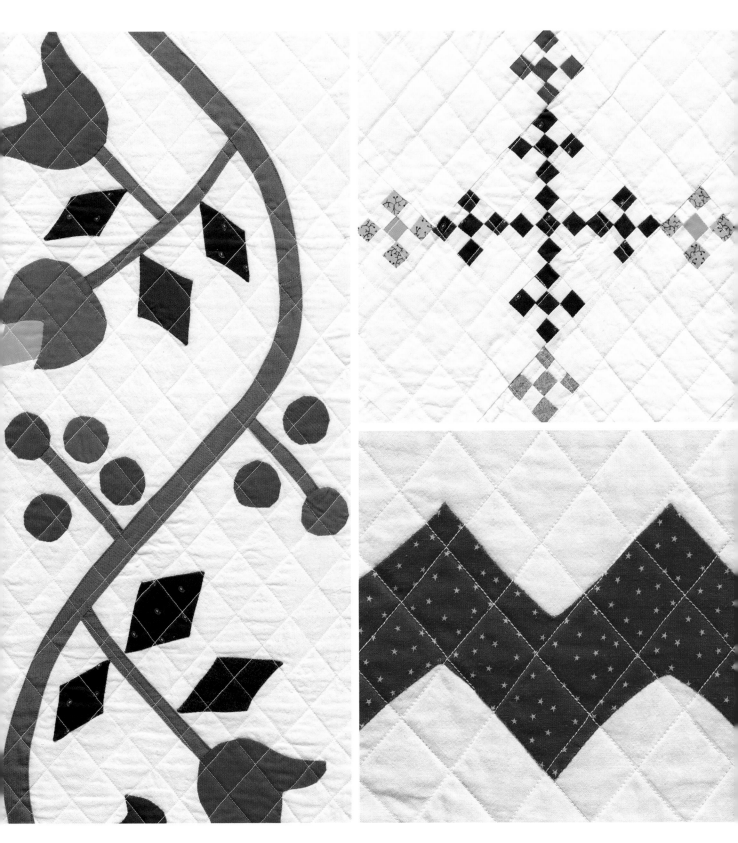

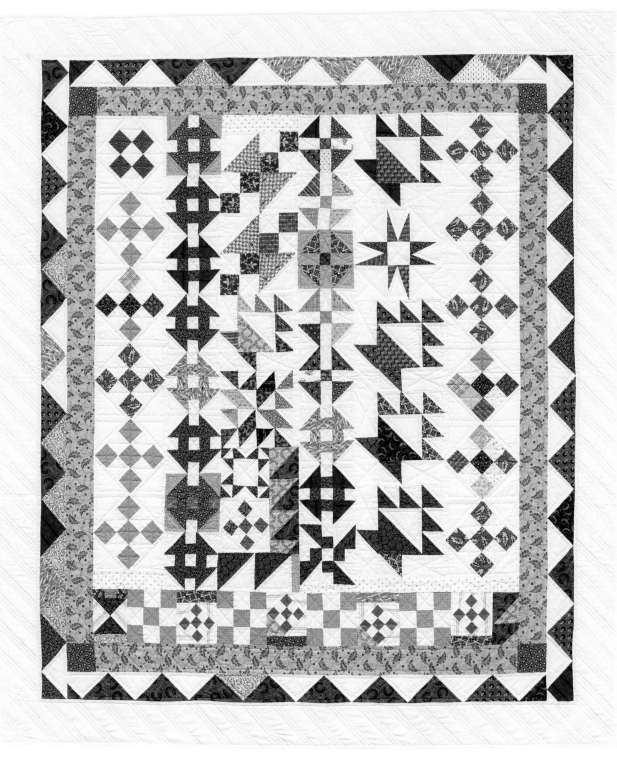

STRIPPY SAMPLER 56" x 63" | 2002

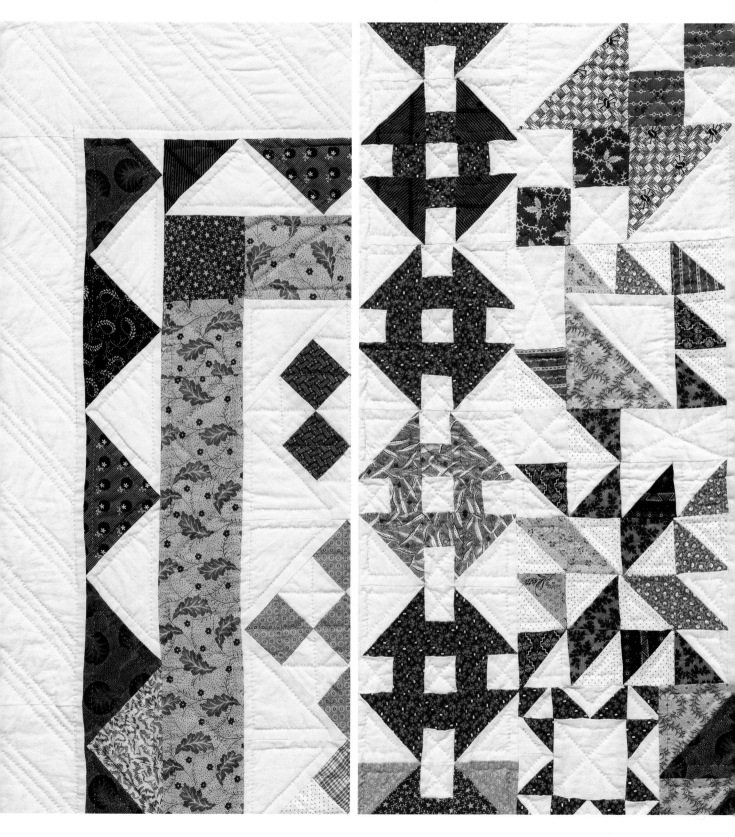

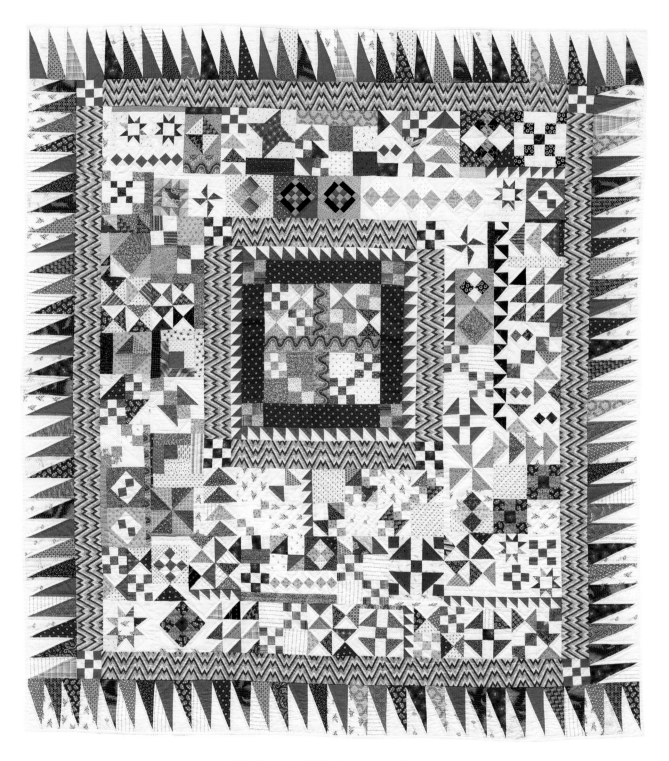

MEDALLION SAMPLER 58" x 62" | 2002

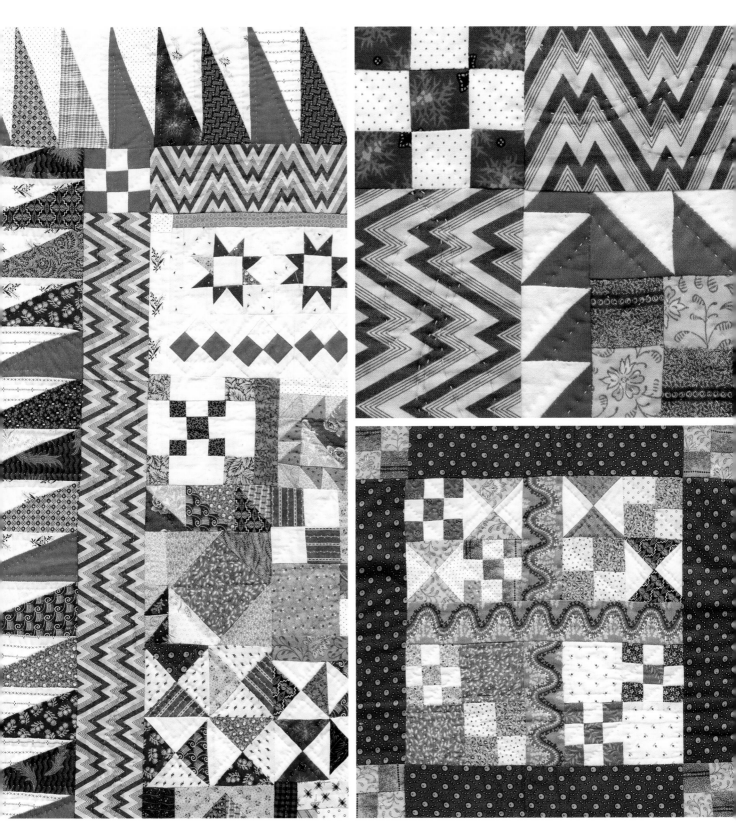

33

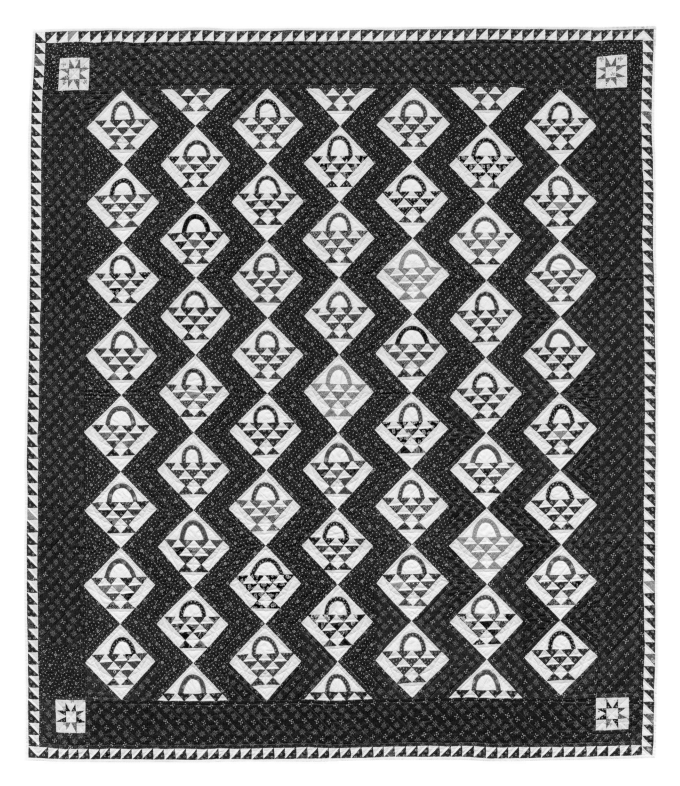

BASKETS WITH STREAK OF LIGHTNING SETTING 60" x 67" | 2005

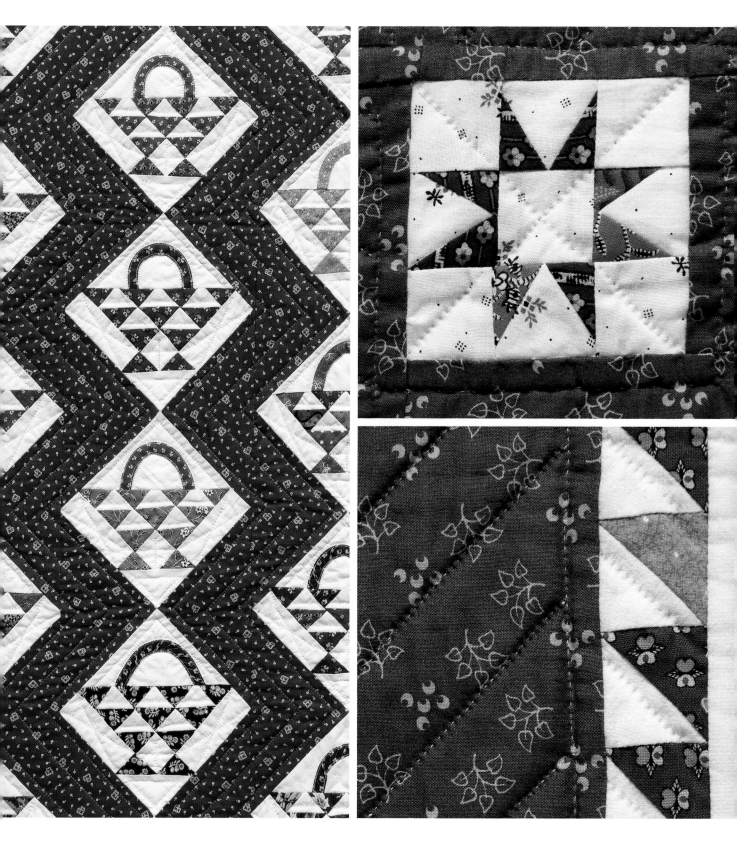

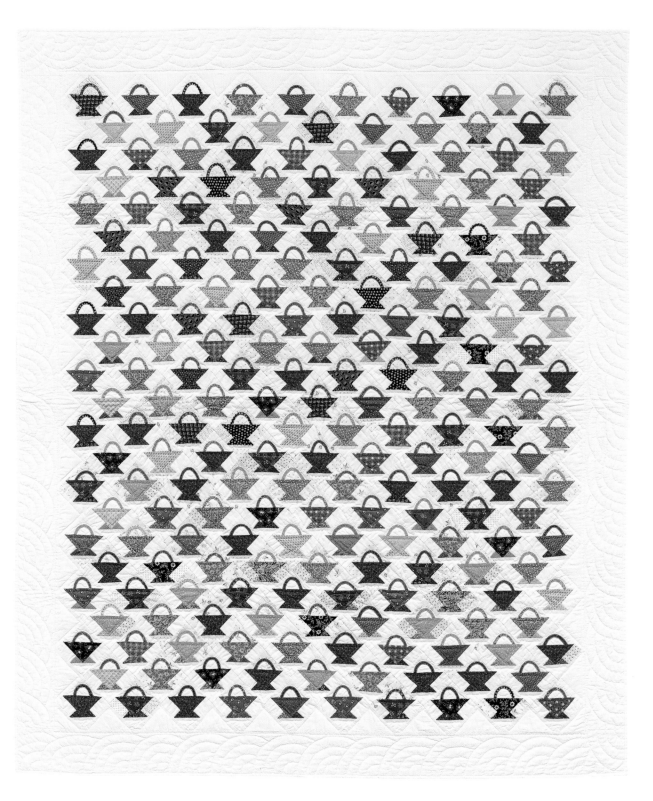

LITTLE BASKETS 64" x 74" | 2006

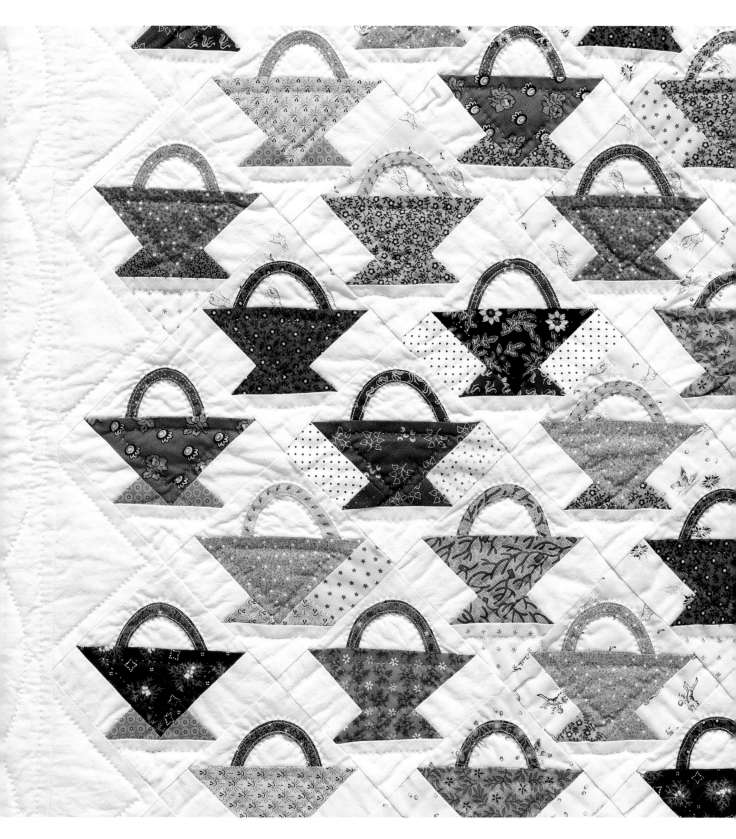

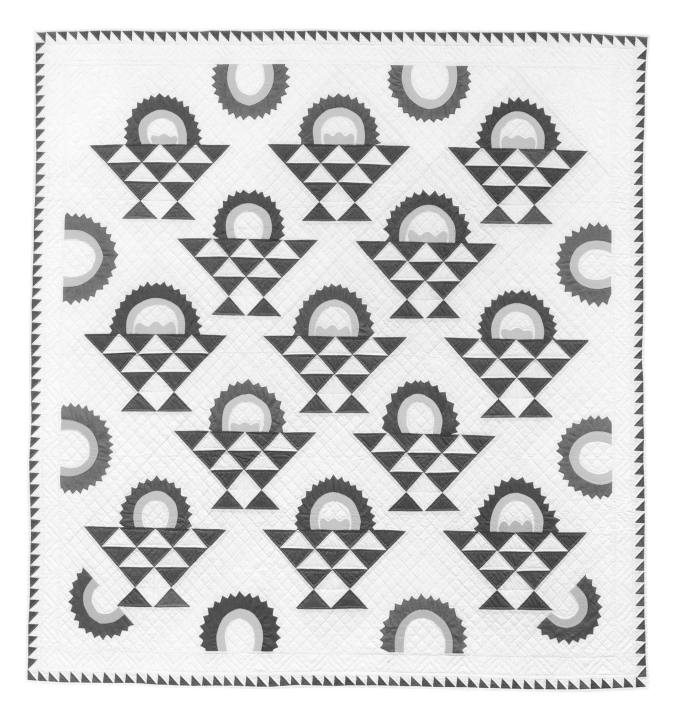

BASKETS WITH DOGTOOTH HANDLES 72" x 72" | 2007

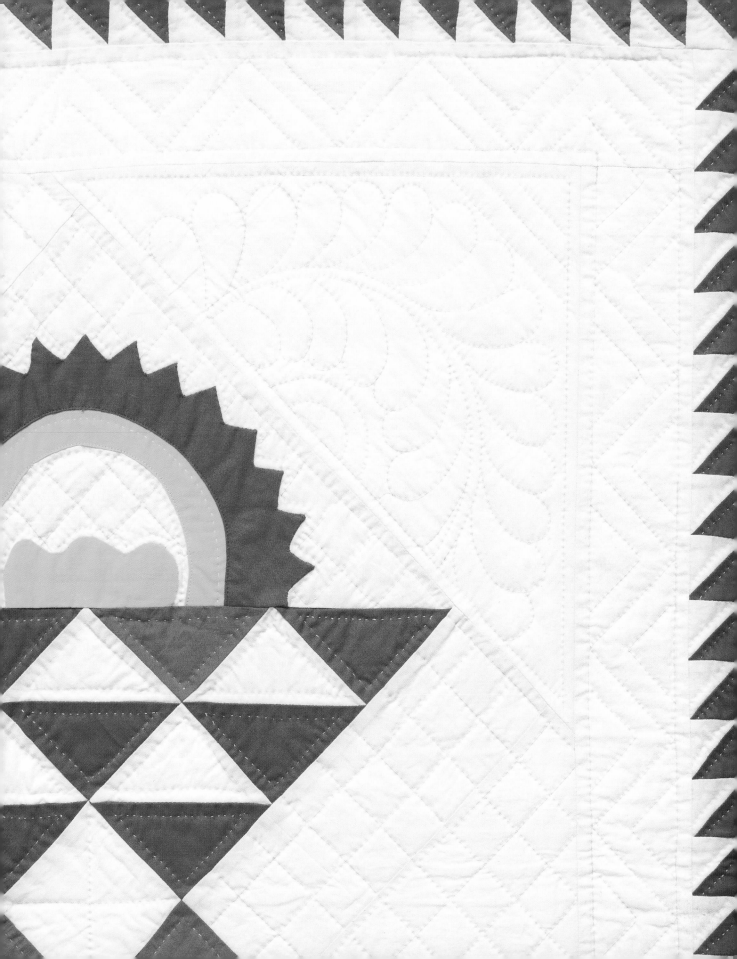

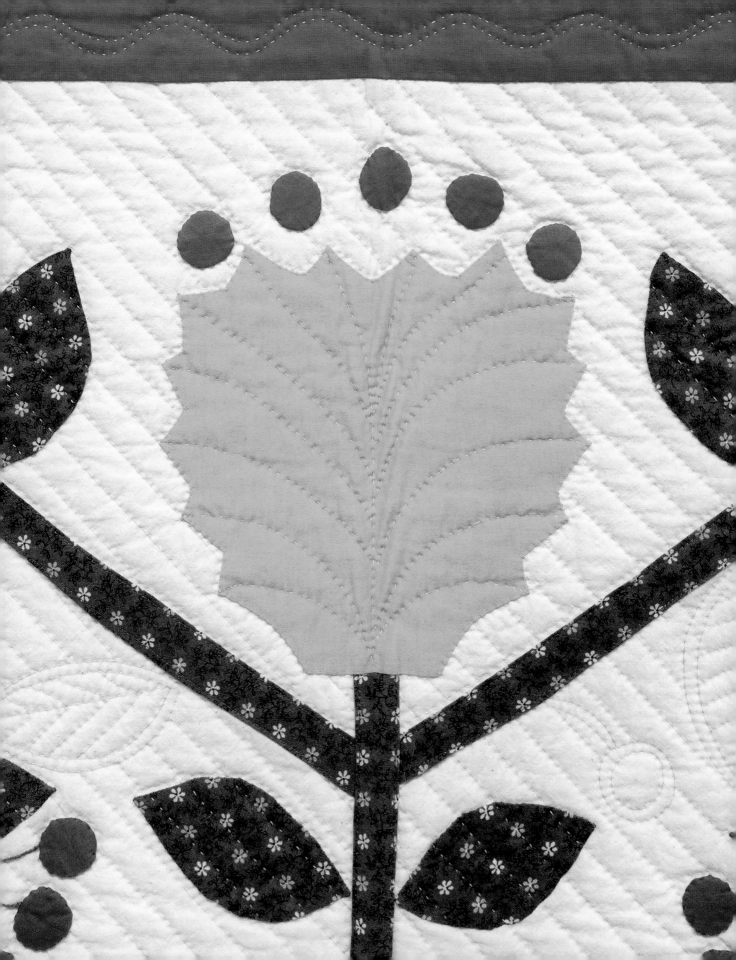

APPLIQUÉ

Being drawn particularly to eighteenth- and nineteenth-century appliqués, I modeled my work after them. What I found engaging about antique appliqués was that repeated shapes were not identical, clearly placement was by eye, and because women were not using printed patterns, even commonly used designs varied dramatically. Wanting to make appliqués in the style of the old ones, I adopted the standard colors of the day and the same techniques used to make them: cutting shapes from folded fabric or by eye, placing them on the background by eye, needle turning the edges under, inviting color substitutes, letting appliquéd vine borders meander unevenly with no thought whatsoever about turning corners symmetrically, and sometimes letting vines run right off the ends of the borders.

As a new quilter, I was fascinated by the quilting designs gracing antique quilts. I set out to learn all I could about them, wanting my quilt designs to be appropriate to the style of the quilt I was making. These designs were often simple yet also sophisticated and refined. Straight-line designs included many variations and were frequently used as background, either on the diagonal or the straight and sometimes running right across the appliqué. Most often the lines were single, but they could also be double or triple. Feather wreaths were common block fillers, and feather vines waltzed irregularly across borders. Sometimes the feathers sprang right off the appliqué vines themselves. Elegant individual designs were also used as fillers: leaves, tendrils, flowers, and grapes. I soon understood quilting played as important a role in the success of a quilt as did the design of the top itself.

Looking at the sampling of my appliqués in this book, you will see that I am most attracted to appliques ca. 1850–80, noted for their bold color and muscular designs that look like they worked out at the gym.

"Never leave home without your appliqué."

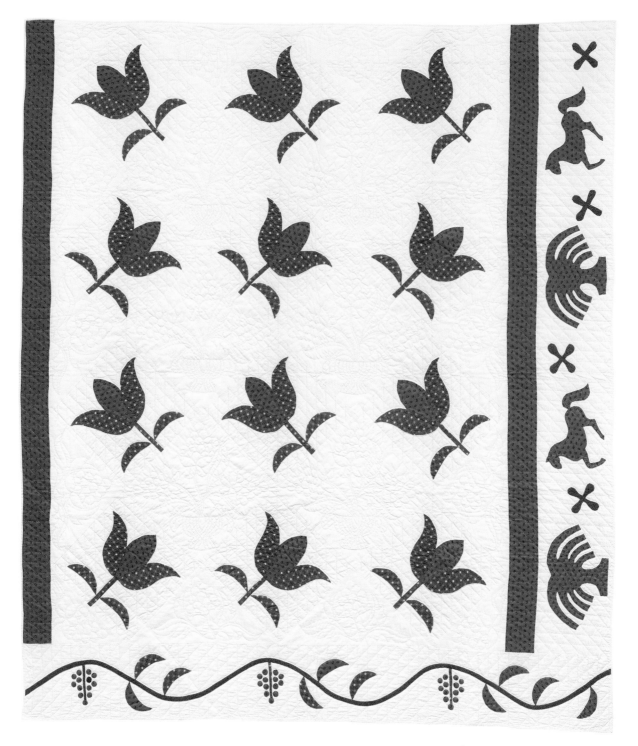

GWEN'S TULIP WITH WILLOW TREES AND HORSES 63" x 76" | 1980

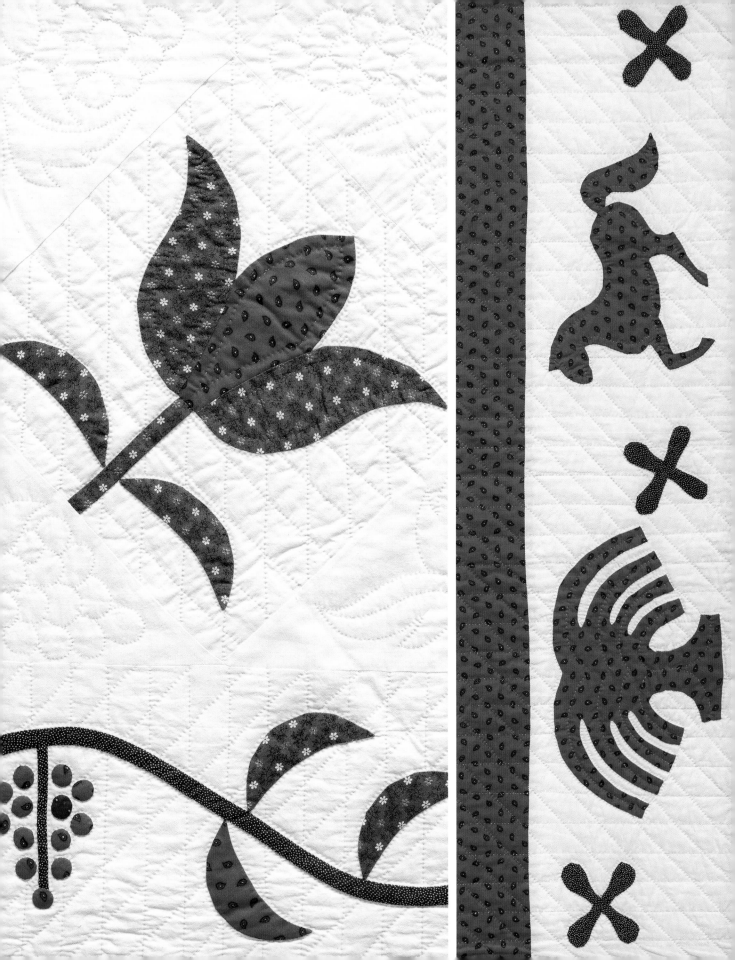

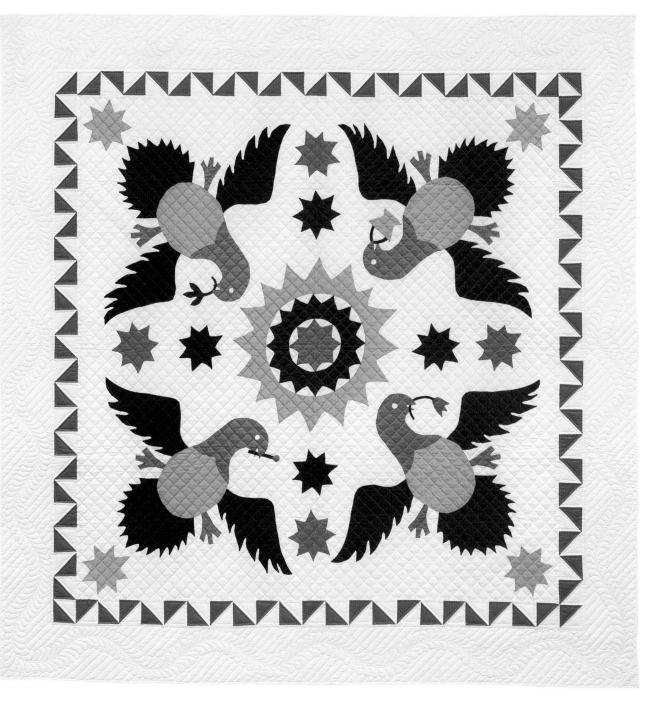

EAGLE 79" x 79" | 1986

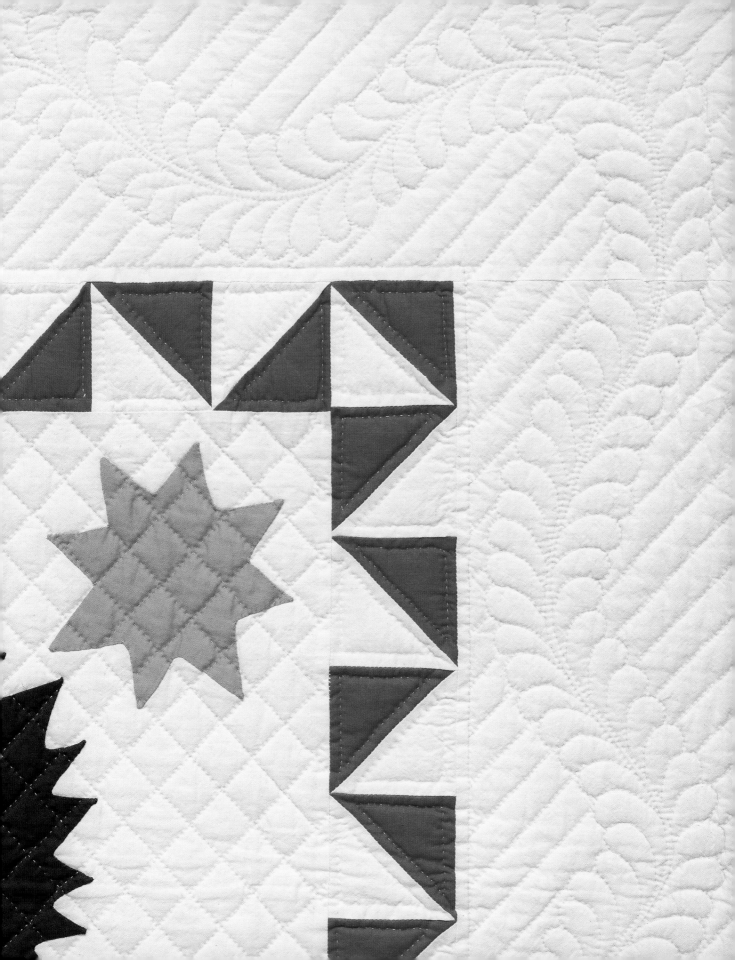

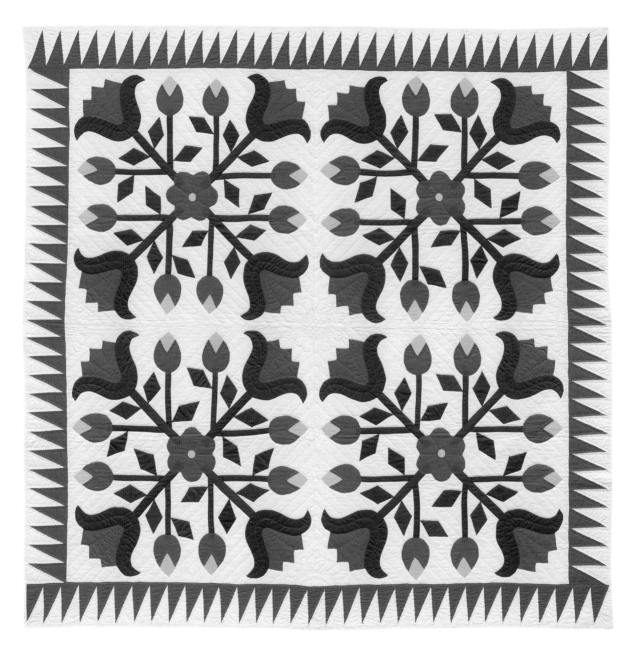

AUNT FRANK'S TULIPS 72" x 72" | 1992

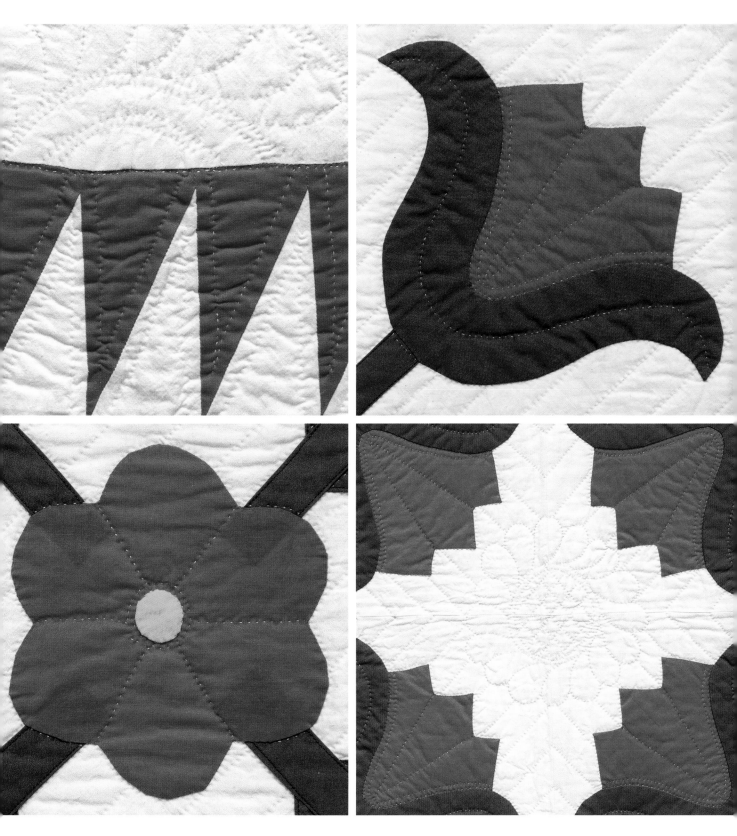

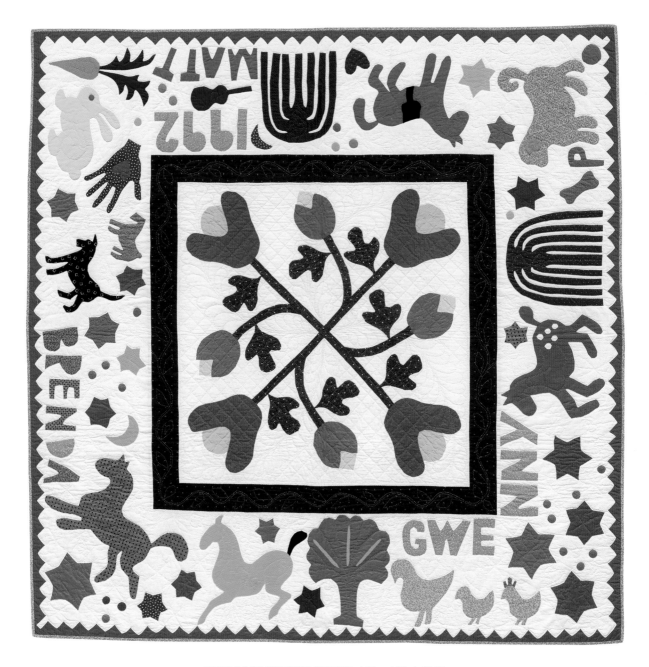

GWENNY'S CROSSED TULIPS 64" x 64" | 1992

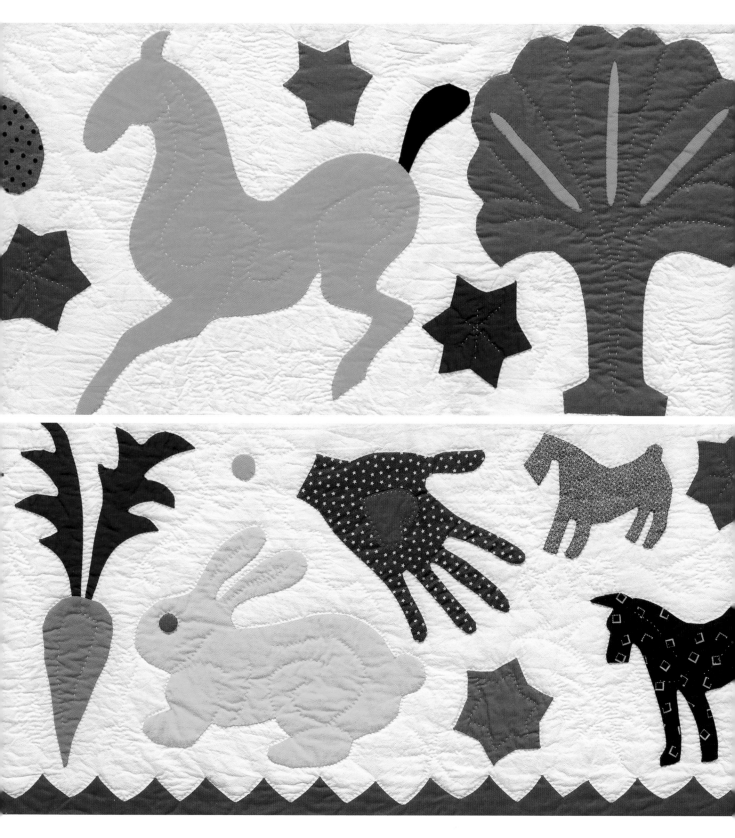

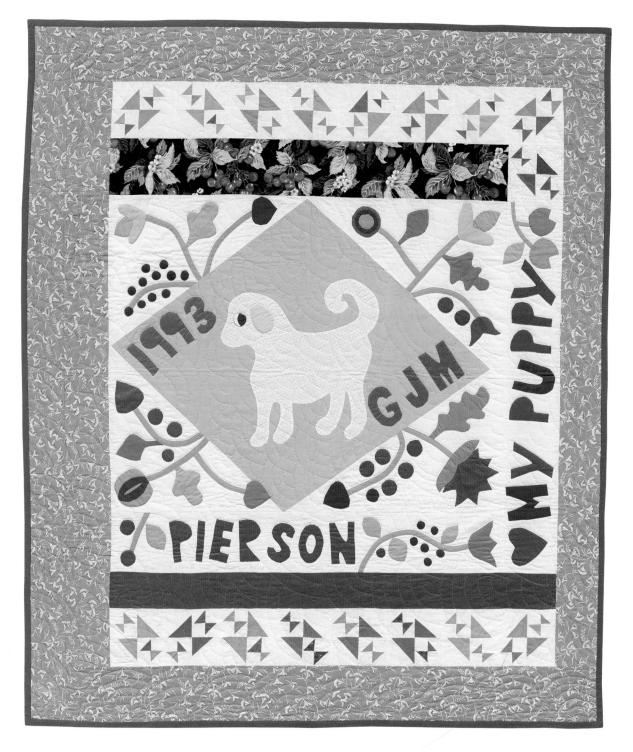

PIERSON 58" x 70" | 1993

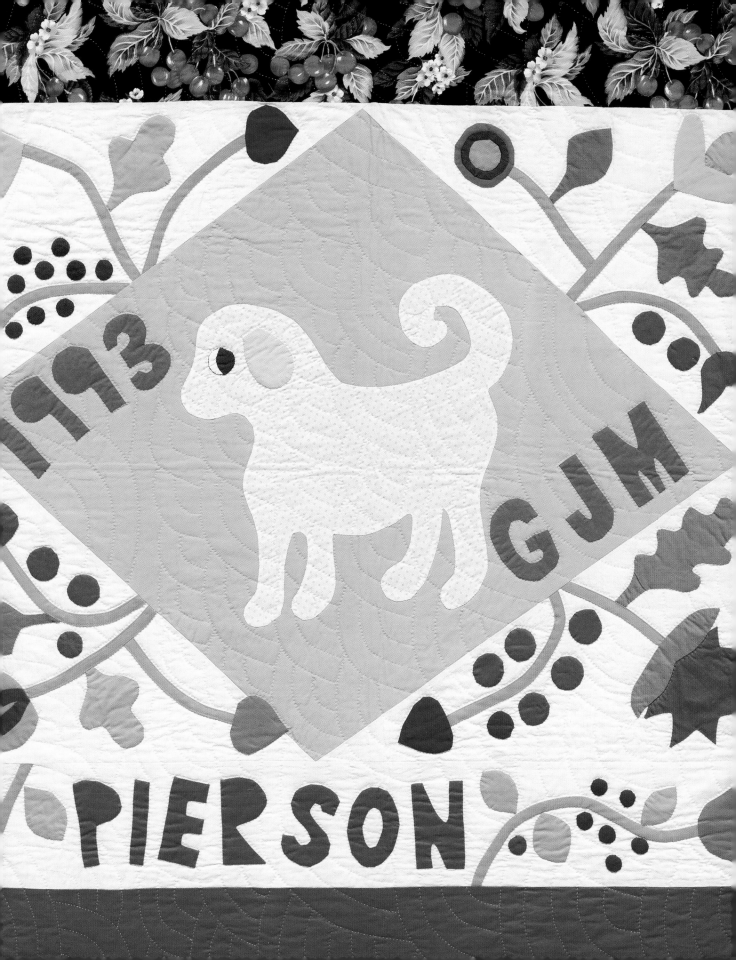

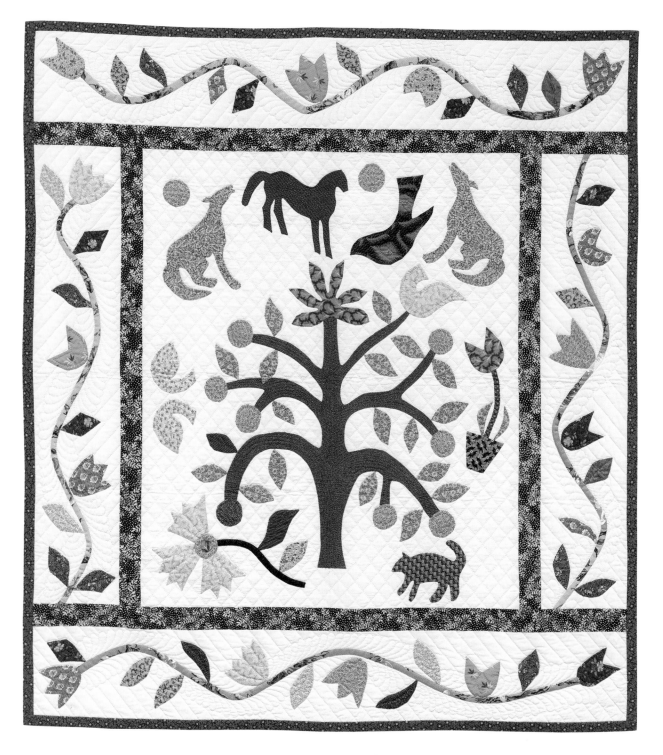

GOD'S DOGS 52" x 58" | 1996

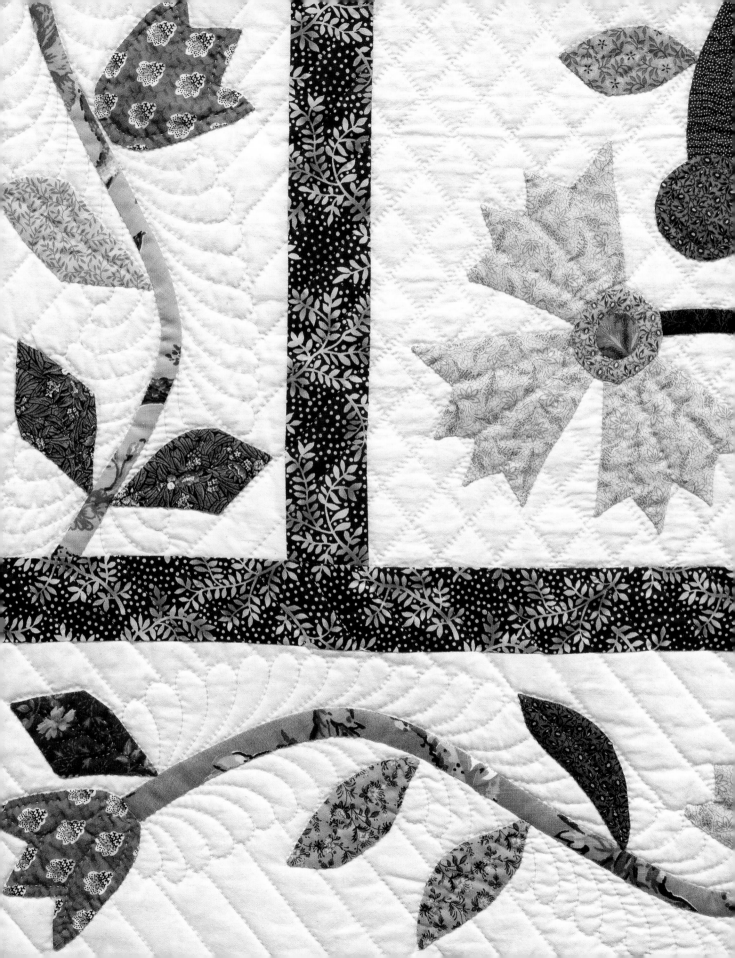

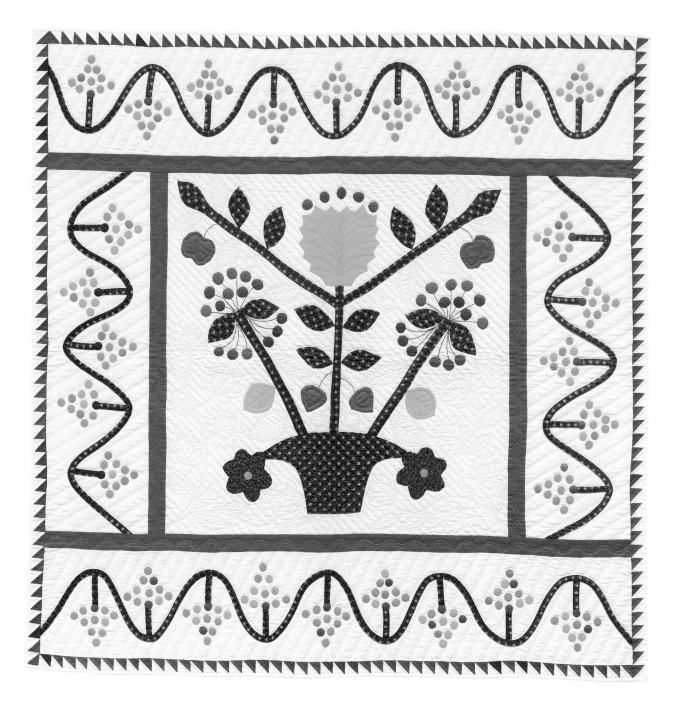

BASKET WITH BERRY BORDER 52" x 52" | 1998

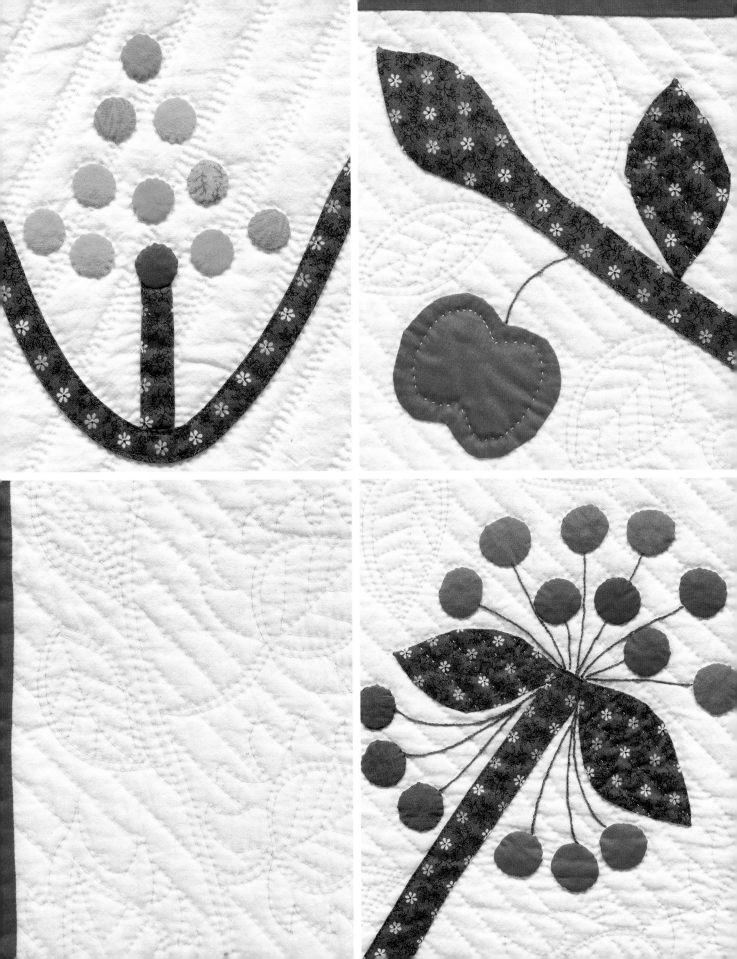

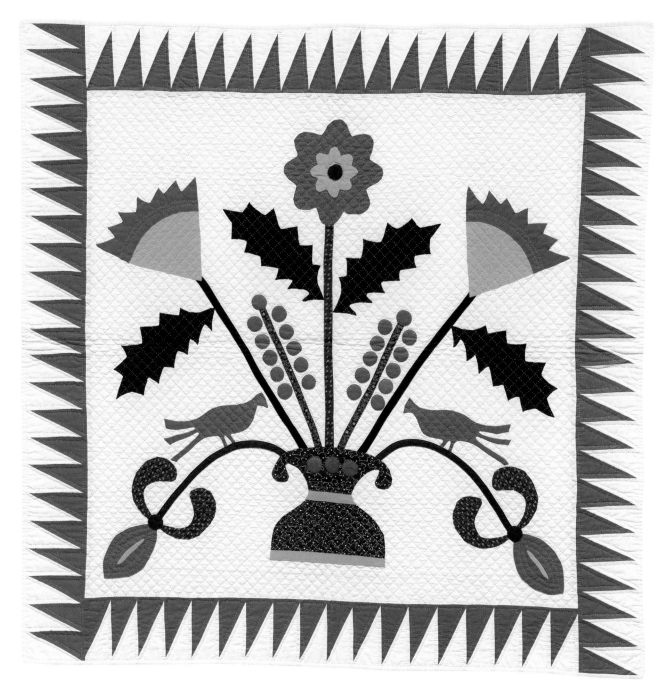

BASKET WITH TWO RED BIRDS 44" x 44" | 1998

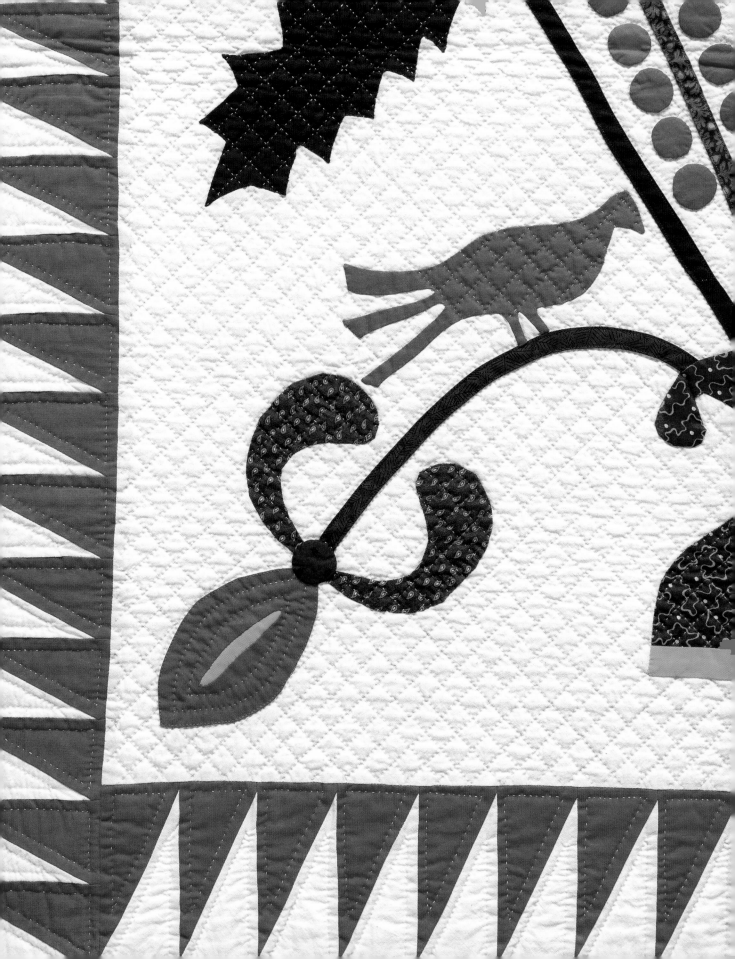

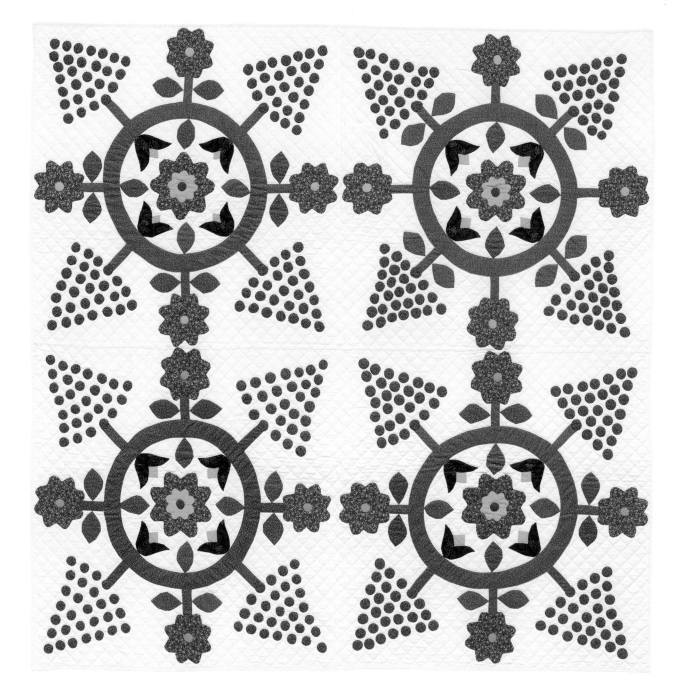

WREATH AND BERRIES 64" x 65" | 1999

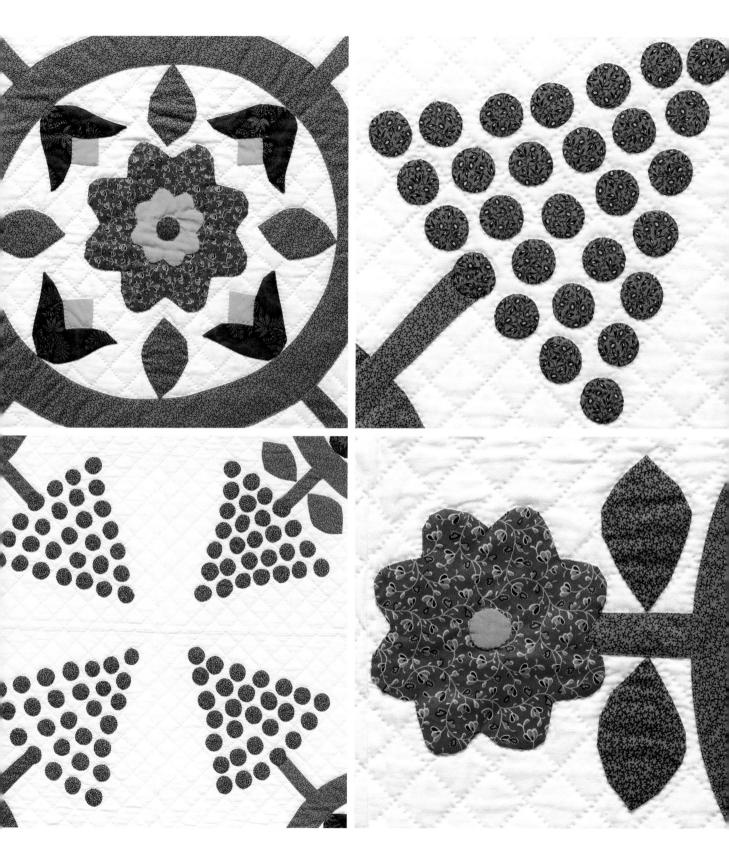

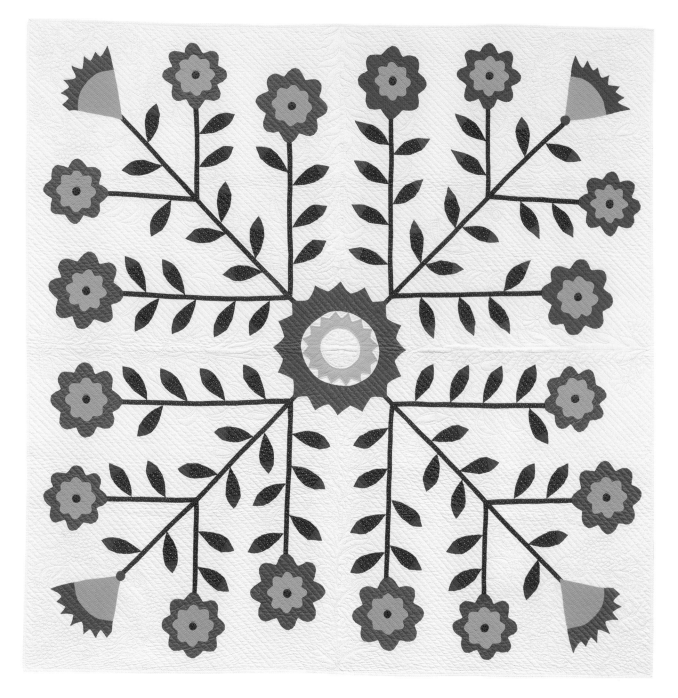

TULIP WITH RED-TIPPED LEAVES 72" x 72" | 2002

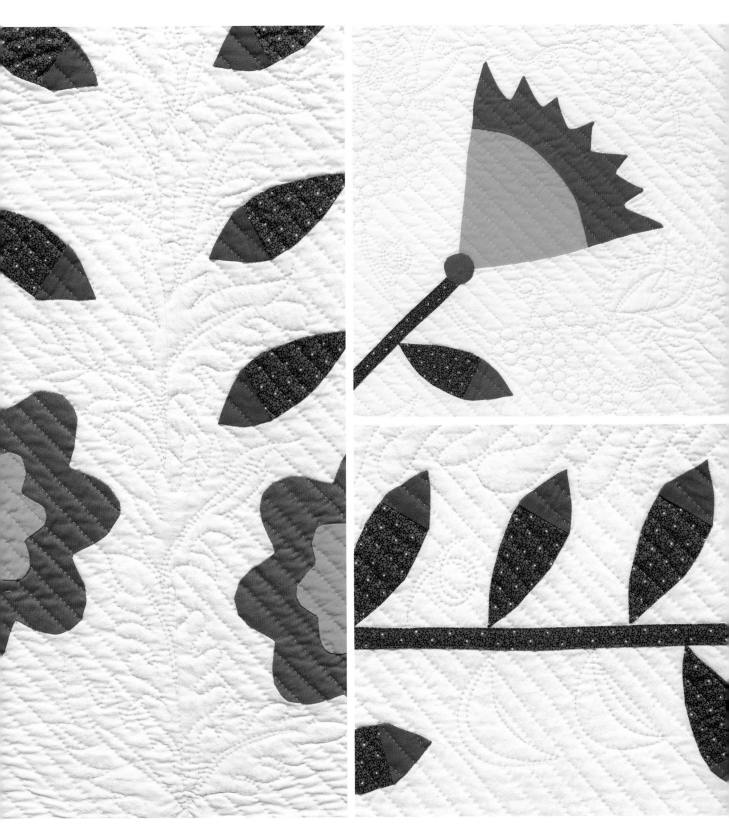

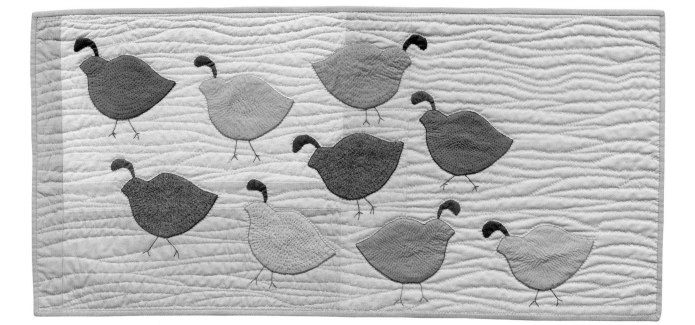

QUAIL 34" x 16" | 2009

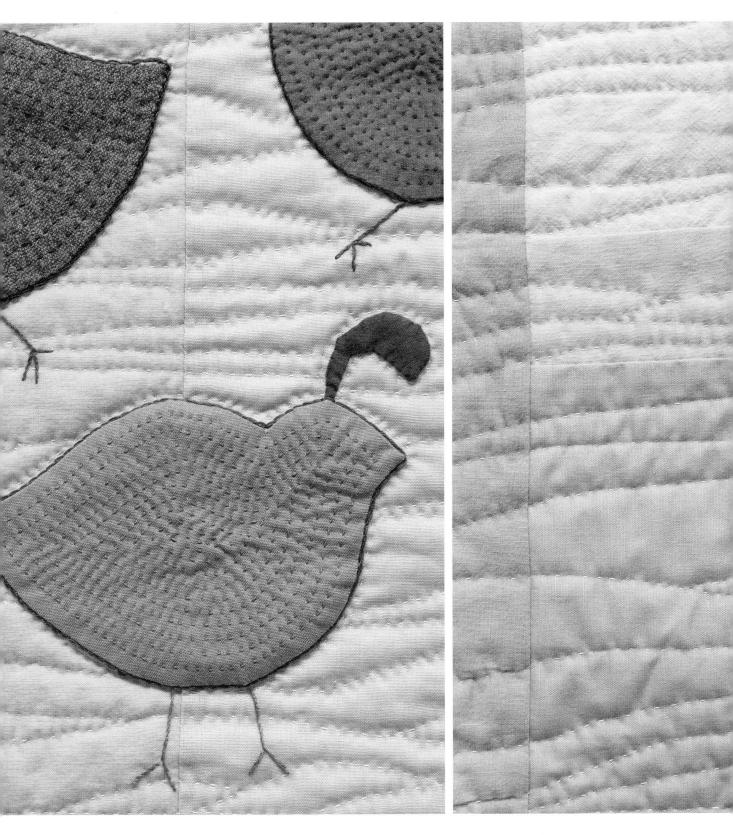

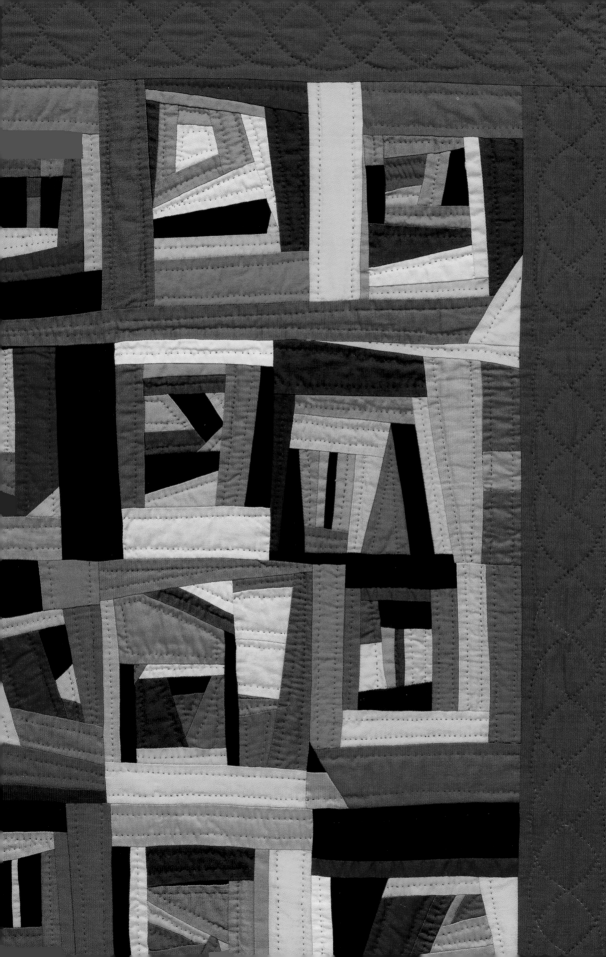

LIBERATED PATCHWORK

Liberated quiltmaking is a phrase I coined in 1990 to describe my new improvisational methods of making quilts that involved free piecing rather than using templates or precisely cut pieces. It is probably what I am best known for and again, I owe this directly to the antique quilts I saw that clearly were not made with a pattern, much less a plan. I began experimenting with constructing blocks similar to those I was finding in old quilts. Eventually I figured it out, and one discovery led quickly to another. I found ways to make traditional blocks without patterns—such as House, Log Cabin, Star, Shoo Fly, Bow Tie, The Exquisite—and free-pieced constructions, such as a series of quilts based on very liberated triangle shapes. I found a way to recut standard blocks for a playful look. I pieced fabric together, which I called Fractured Fabric, and used it to make blocks.

Eventually I shared these new ideas in a book called *Liberated Quiltmaking* (AQS, 1996). This book was a process book, not a project book. Instead of giving directions for making a whole quilt, I explained the process for making the parts of the quilt, leaving the size and number of blocks and the finished size of the quilt up to the maker.

A liberated style of quiltmaking has provided me, as well as many others, with a way to do original work. Each quilt is unique and cannot be duplicated, not even by its maker. It opened the door that allowed quilters a way to create their own work instead of buying yet another pattern designed by someone else. Doing your own work is rewarding and affirming, and everybody deserves that.

"I owe liberated patchwork directly to the antique quilts that clearly were not made with a pattern, much less a plan."

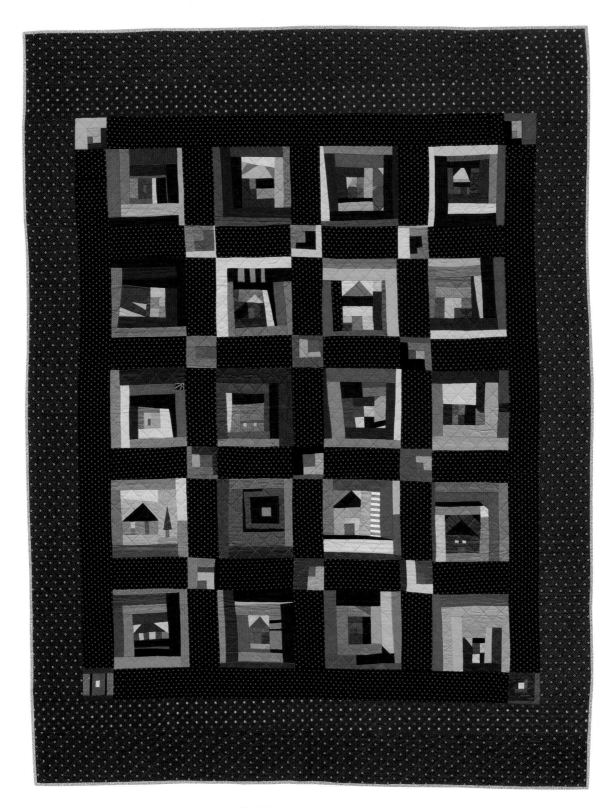

HOUSES 56" x 72½" | 1990

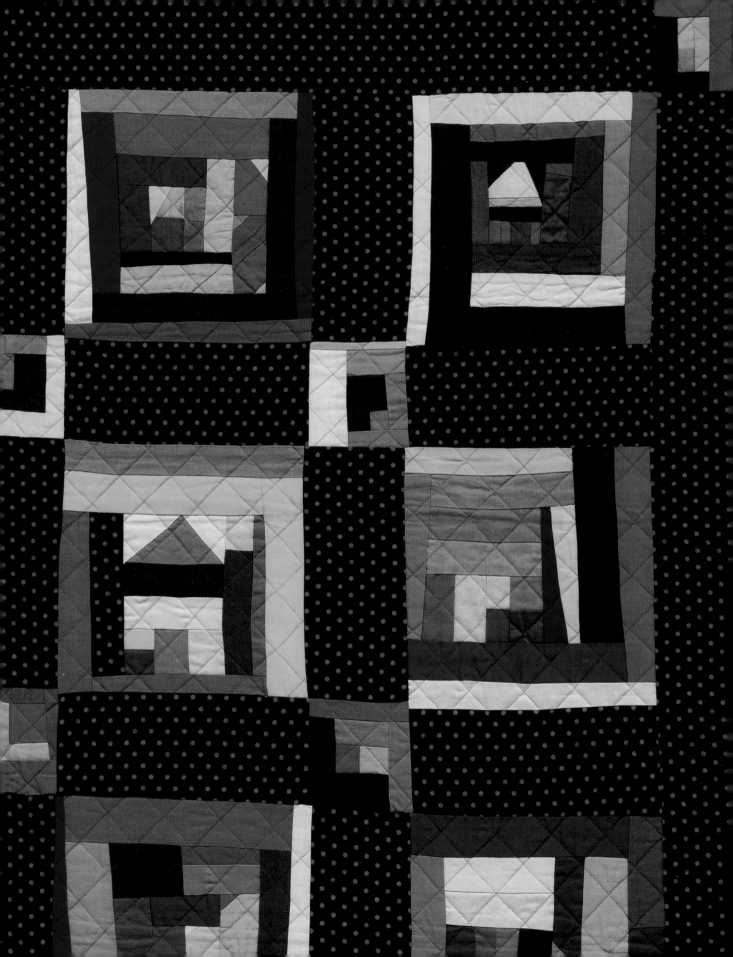

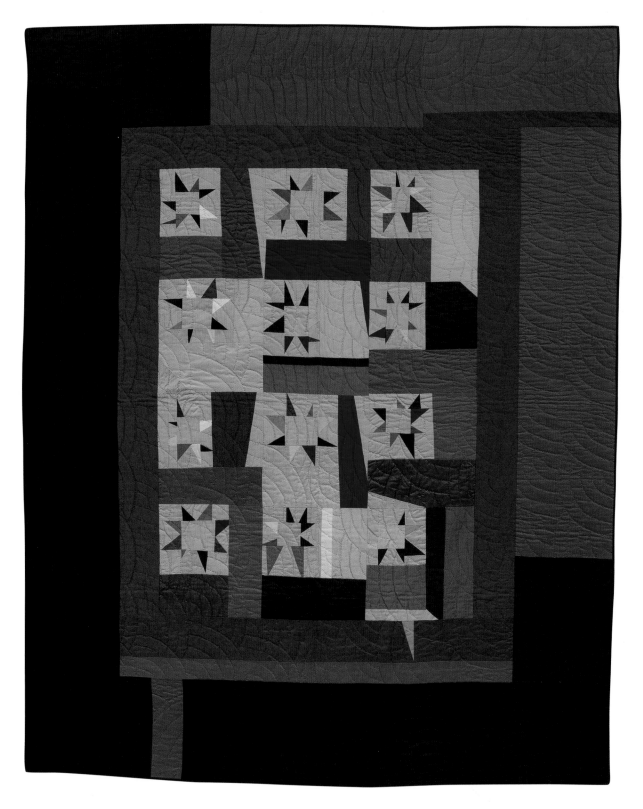

VARIABLE STAR 60" x 70" | 1991

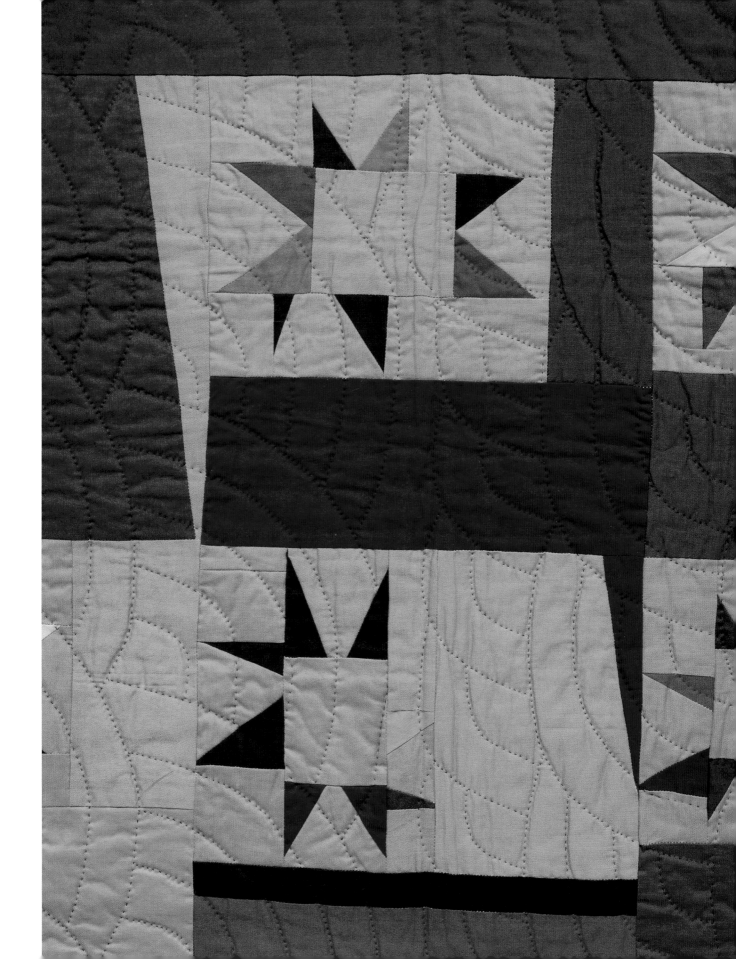

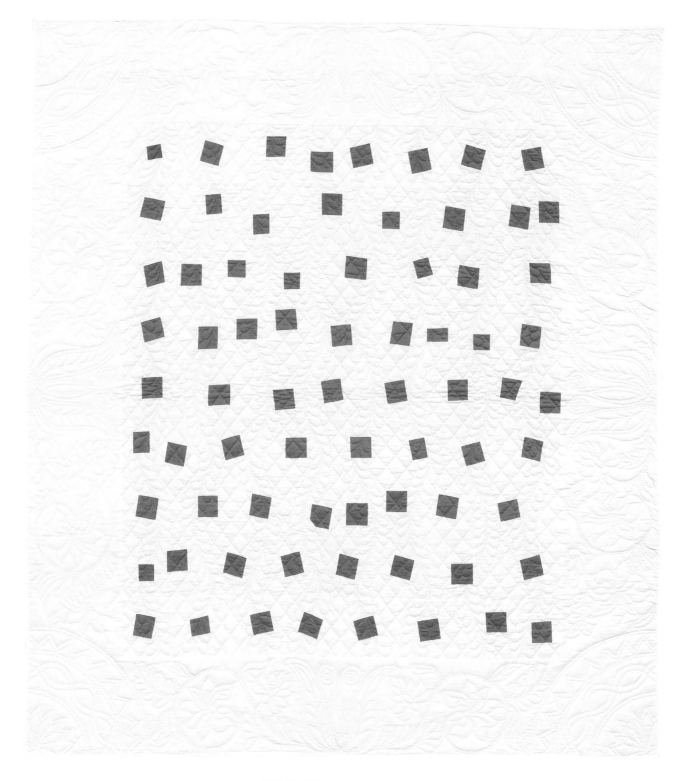

RED SQUARE 62" x 70" | 1993

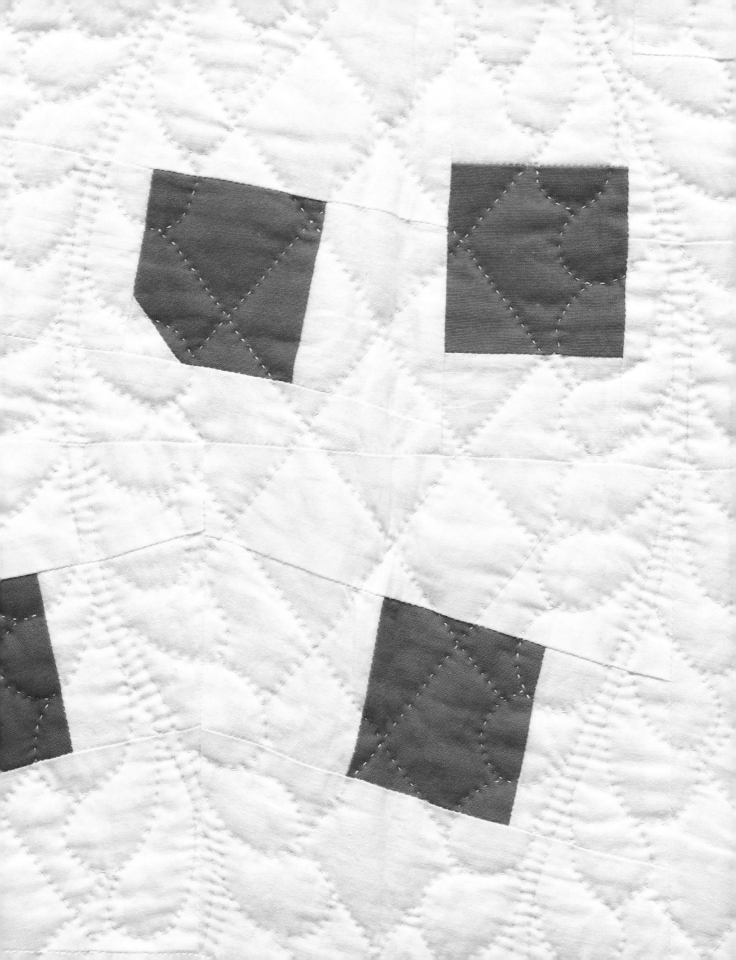

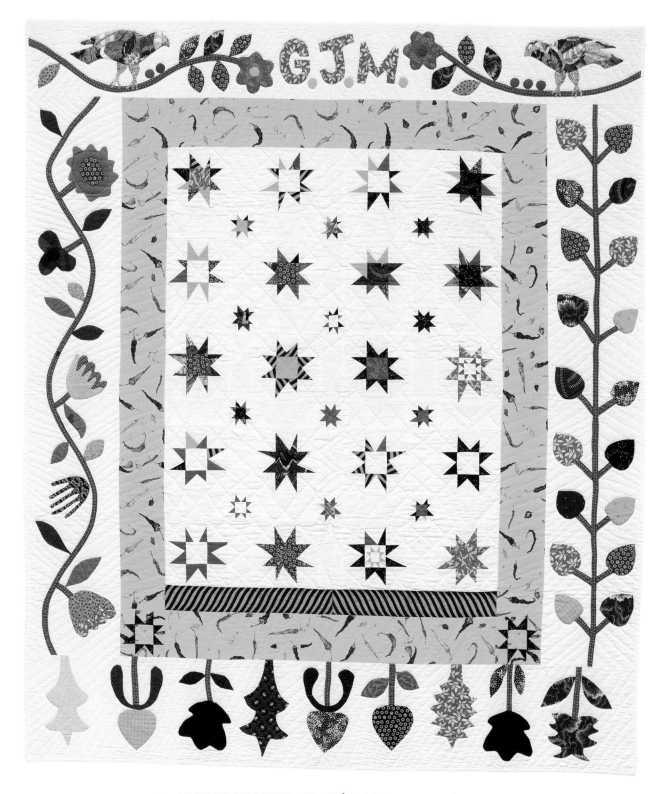

VARIABLE STAR WITH APPLIQUÉ BORDER 56" x 66" | 1995

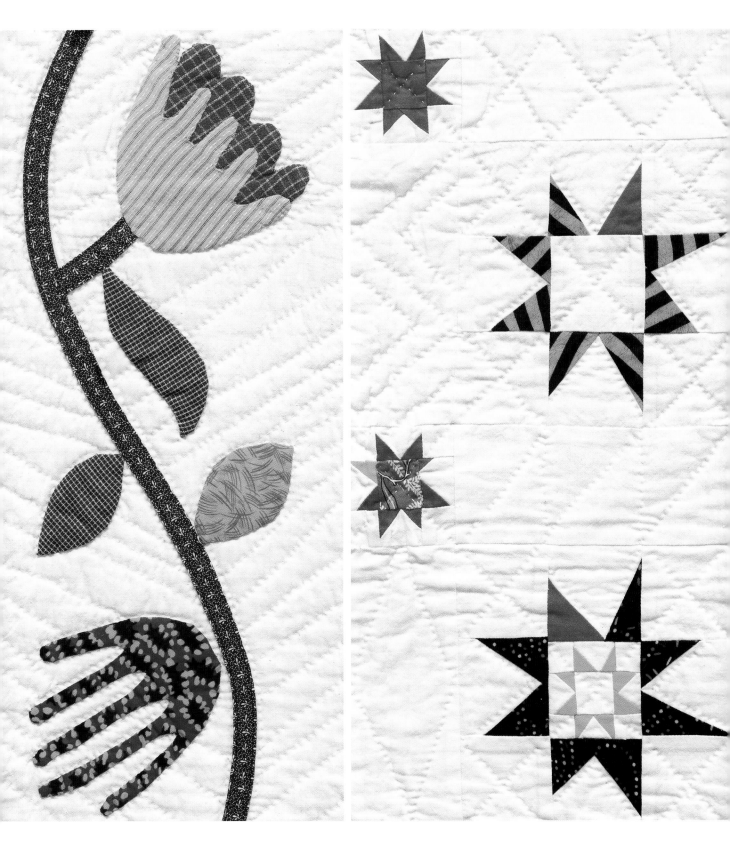

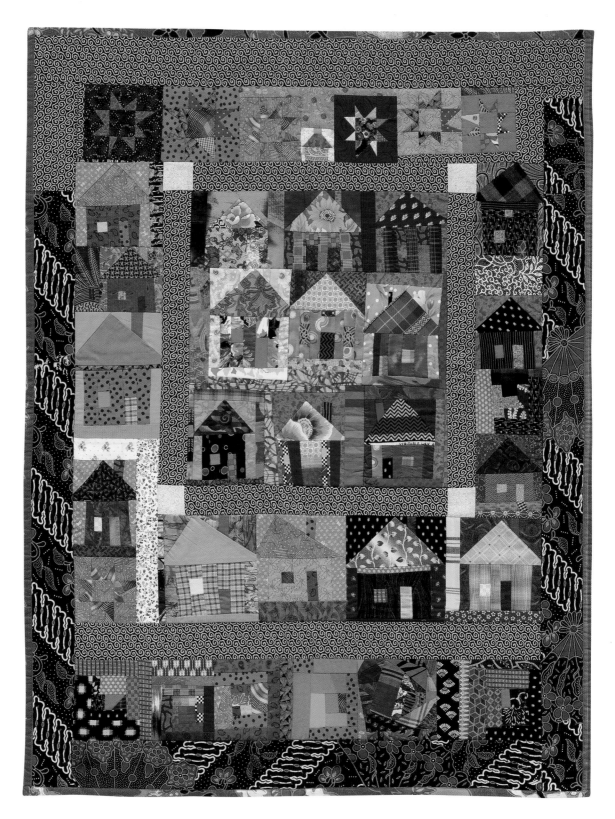

THE GLOBAL VILLAGE 40" x 50" | 1995

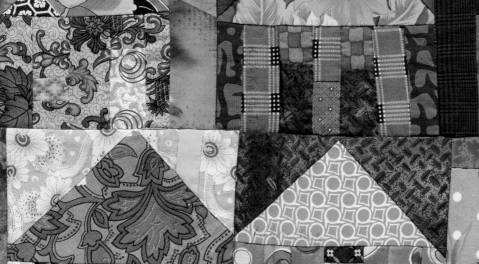

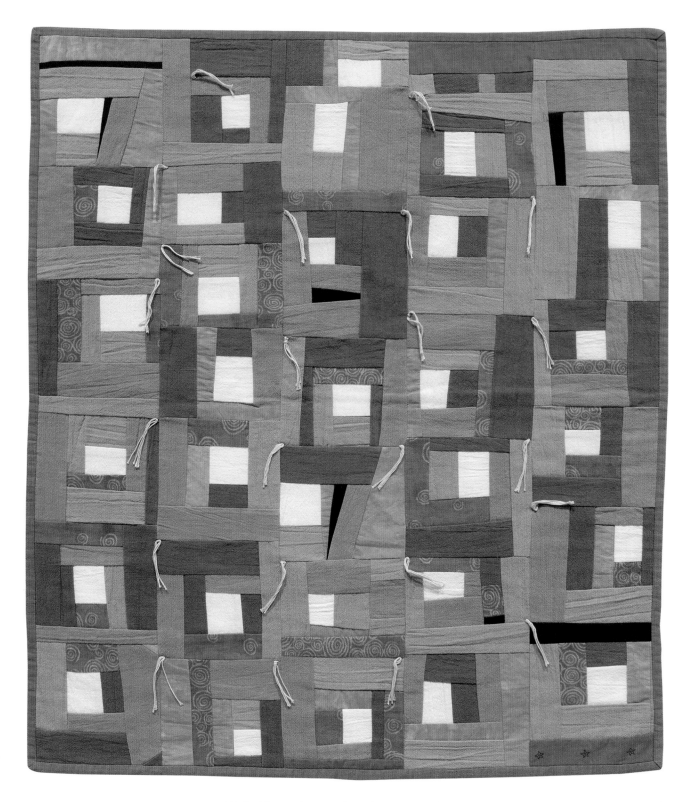

LIBERATED LOG CABIN (TIED) 28" x 32" | 1997

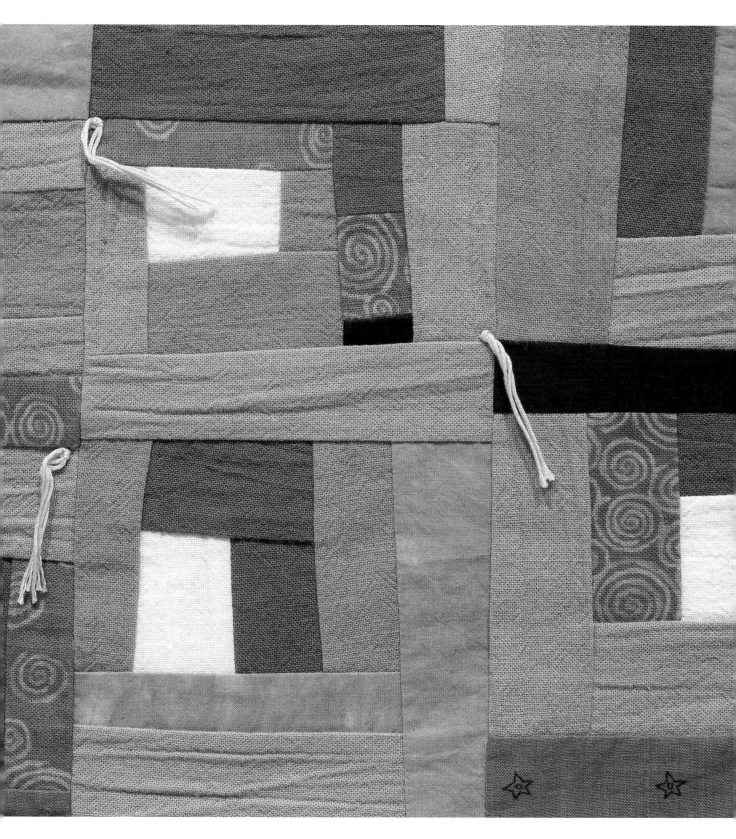

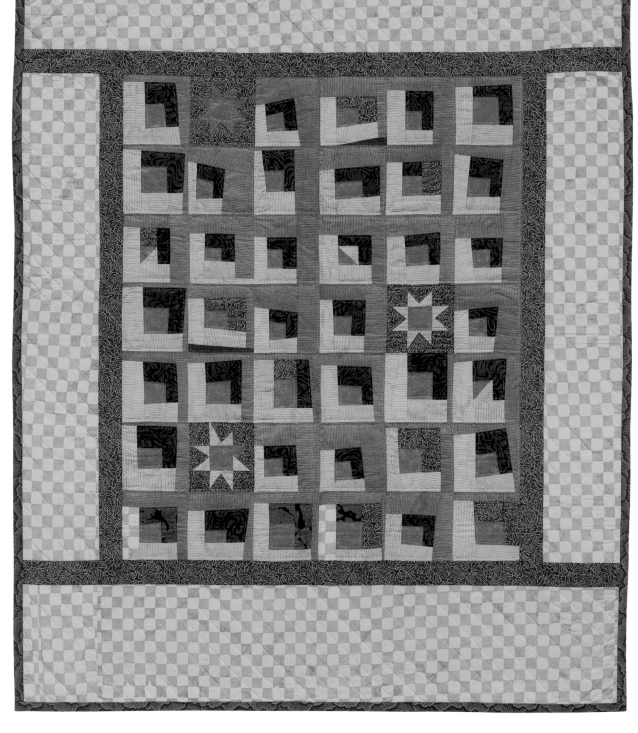

LIBERATED LOG CABIN AND STARS 42" x 49" | 1997

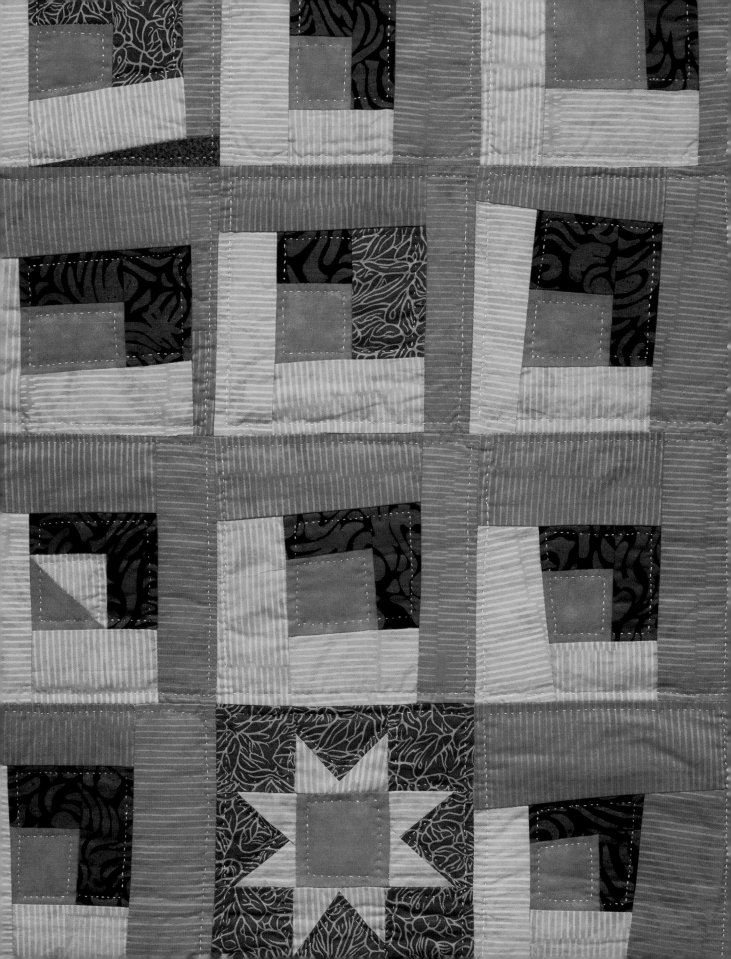

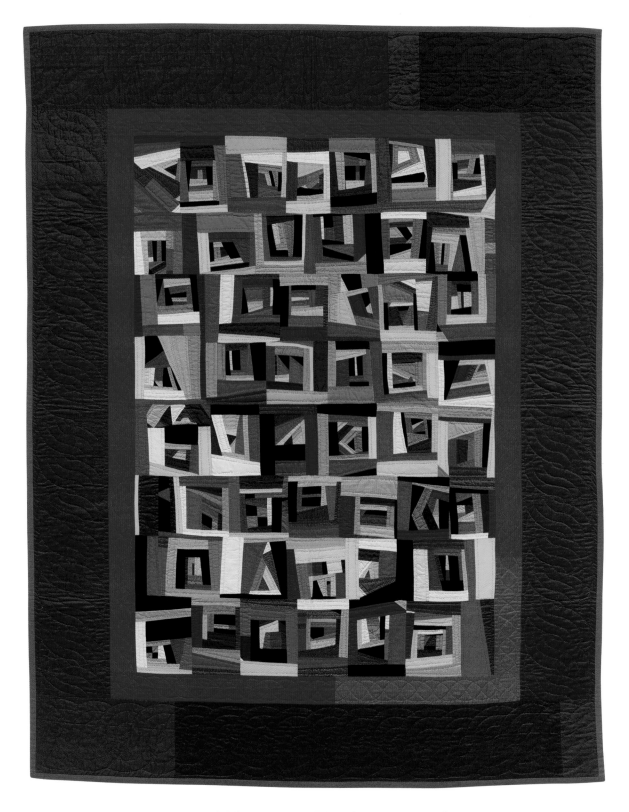

LIBERATED LOG CABIN WITH PURPLE BORDER 58" x 73" | 2000

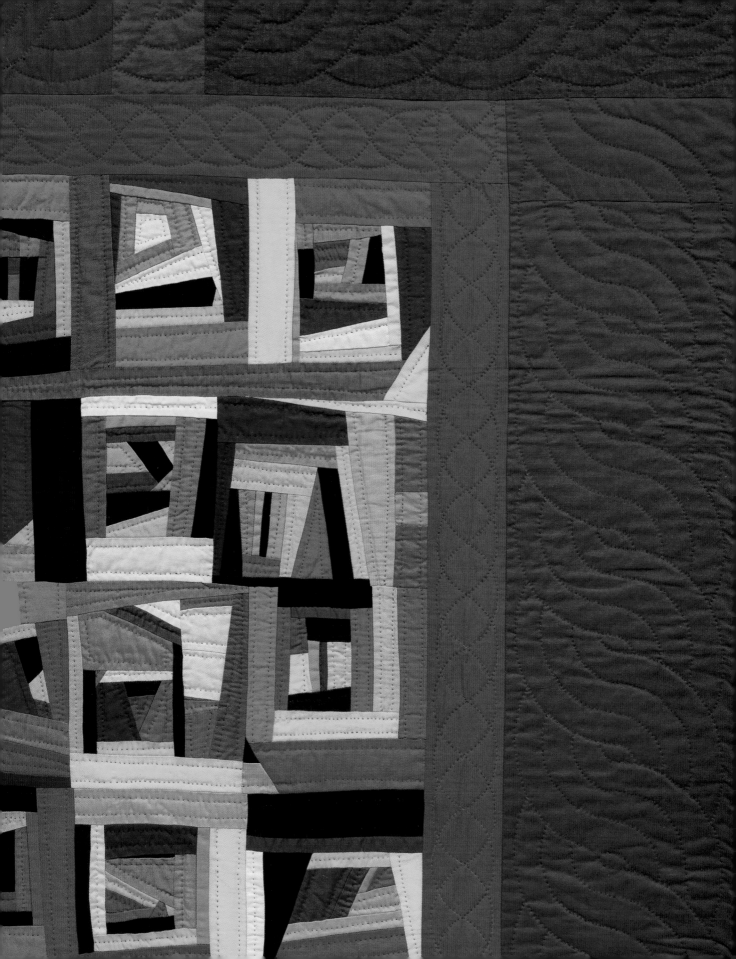

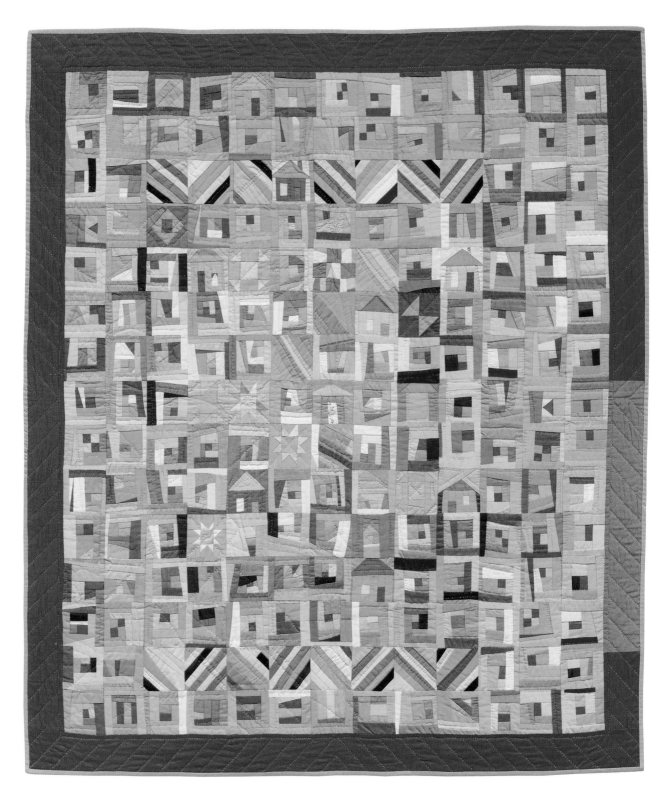

SUMMER FRUIT SALAD 44" x 51" | 2001

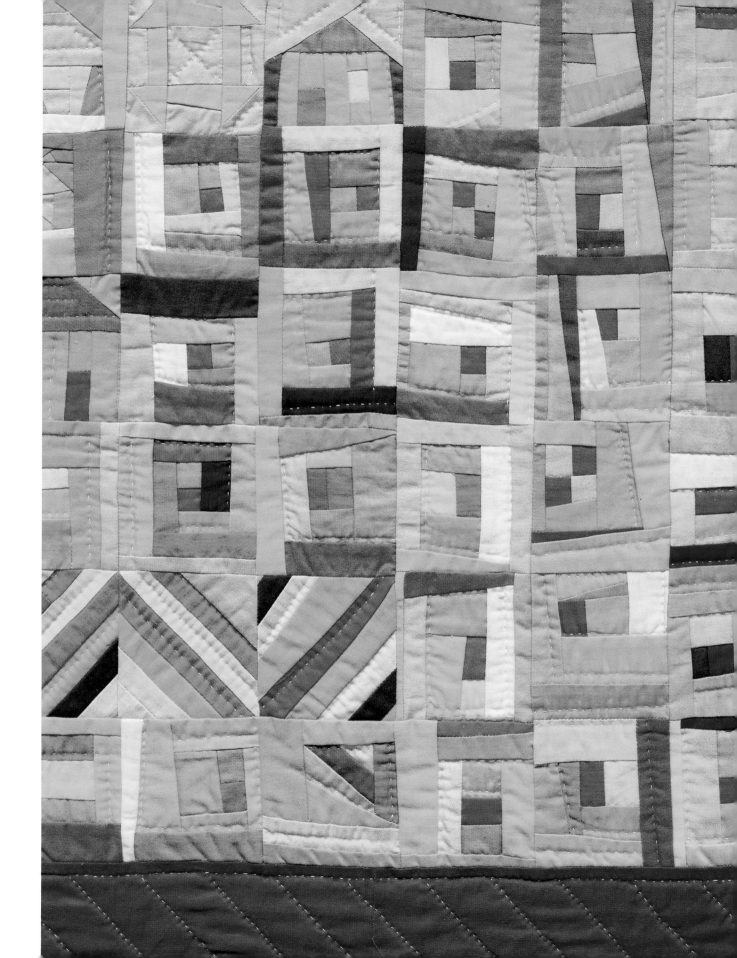

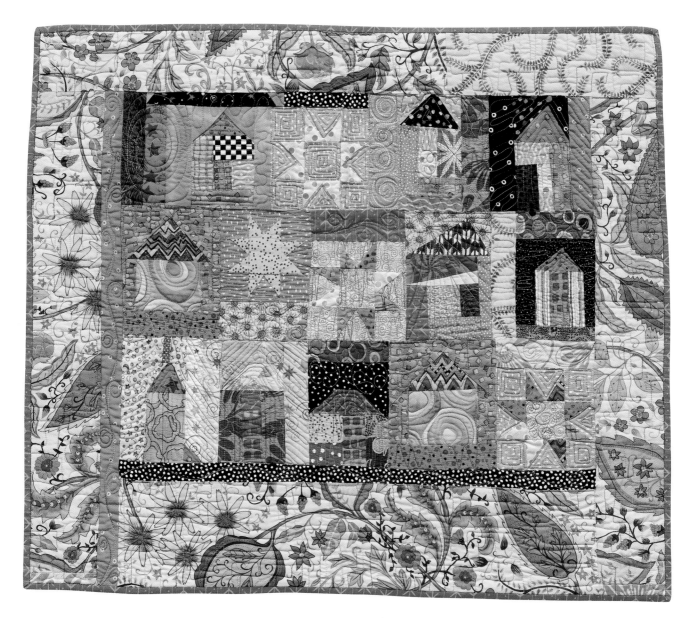

SAMPLER 29" x 25" | 2002

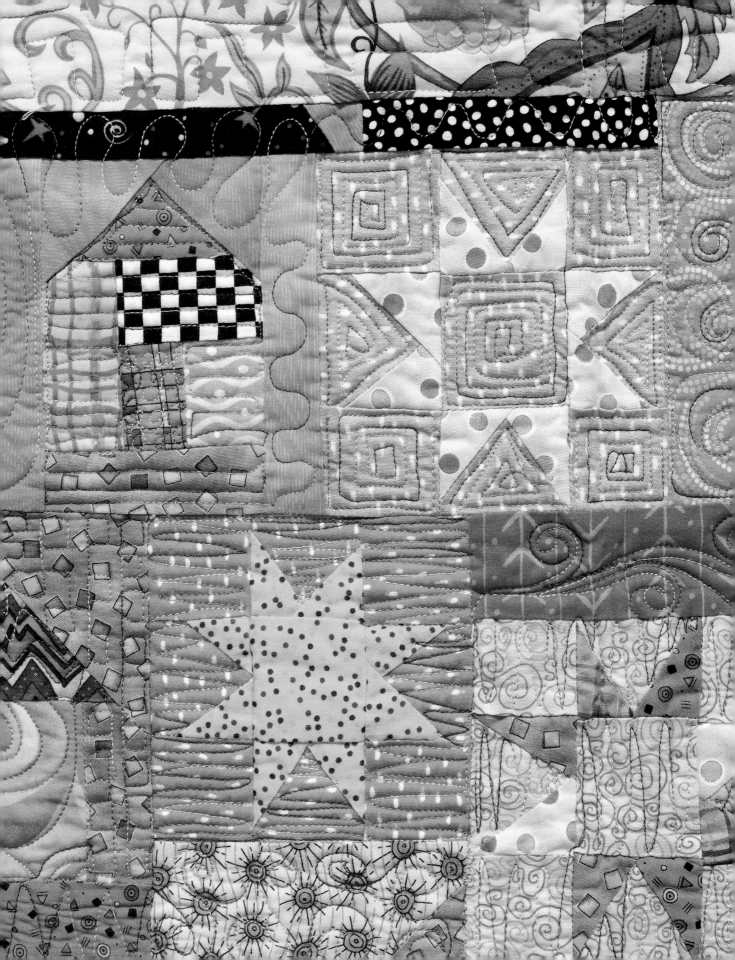

LITTLE STARS 67" x 74" | 2004

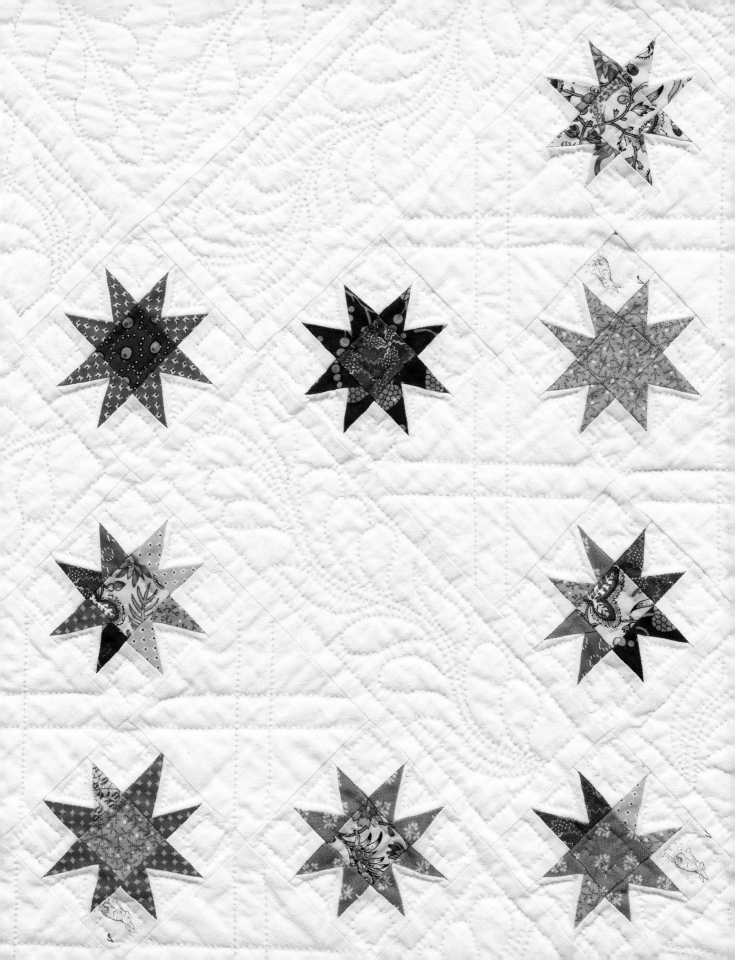

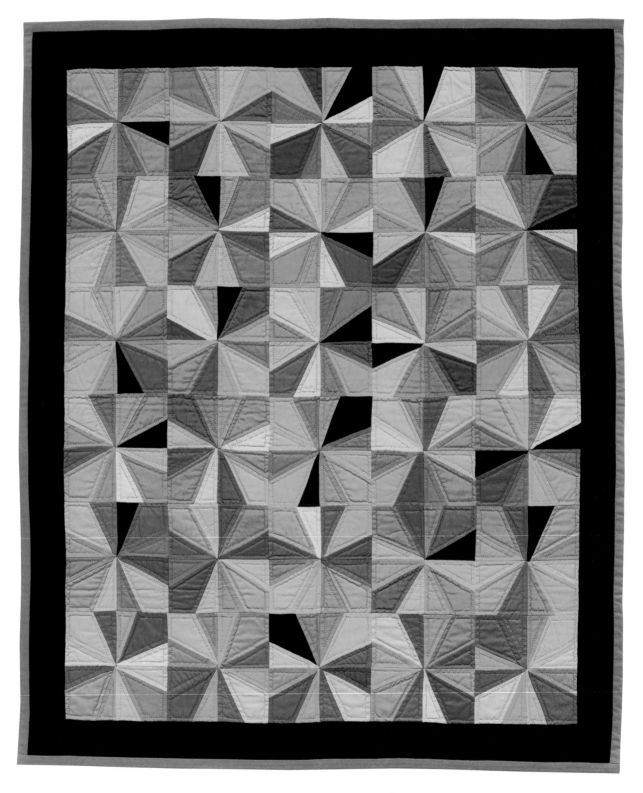

MEXICAN HAT DANCE 40" x 47" | 2008

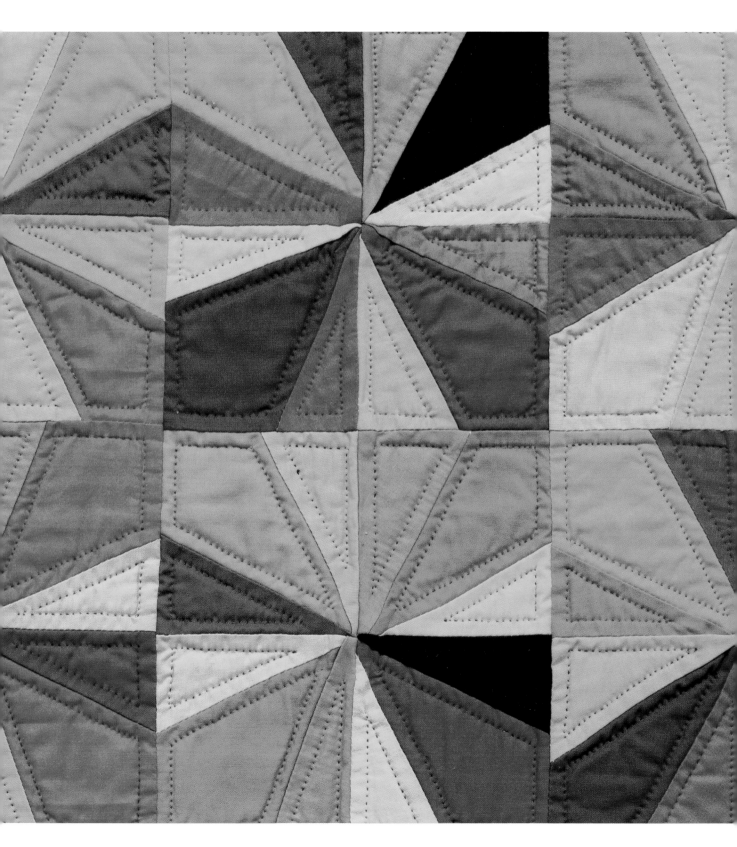

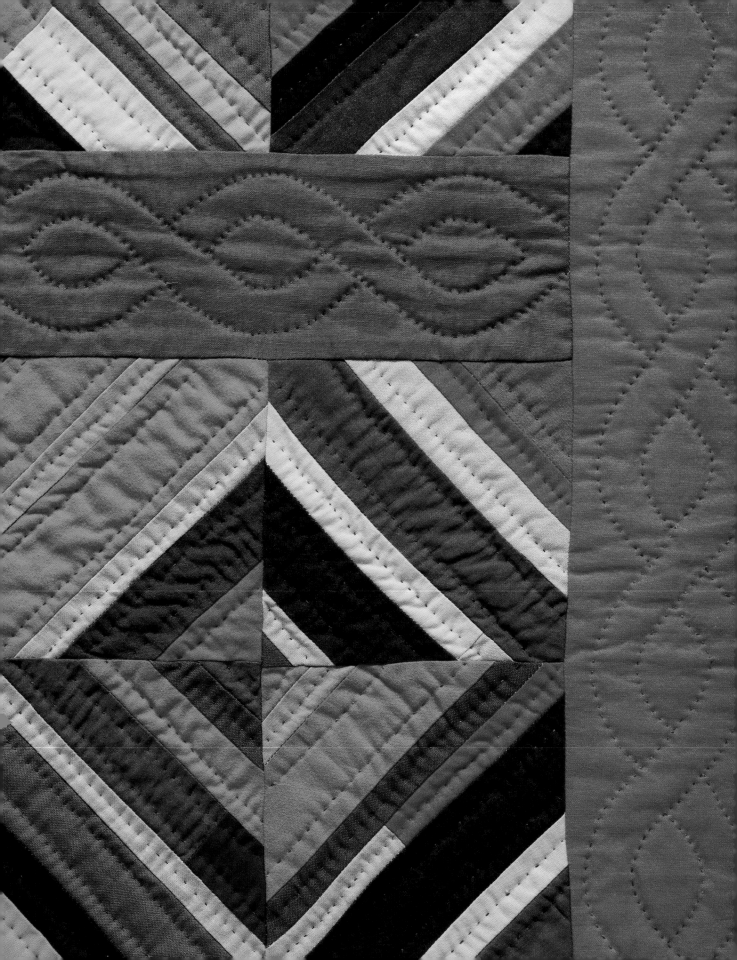

STRING QUILTS

String quilts are improvisational, neither planned nor manipulated on a design wall and therefore just perfect for the "liberated" quiltmaker. They were typically made with narrow strips and little scraps too small to use for anything else, stitched together quickly and sometimes crudely by women in a hurry to make a bedcovering to keep their families warm. Because of the way they're made there are no two alike. They are all original. I consider them the Jackson Pollocks of the quilt world, ever as vibrant, spontaneous, and dramatic as his paintings. In my view they move to the head of the class we call art quilts. And because they were made without pretense, by people of few means, string quilts ring of social justice to a liberated quiltmaker like myself.

While string quilts were historically made on a foundation, I found a way to piece them without a foundation while still getting the classic string look.

"A look at antique string quilts is a humbling experience. One after another, they dazzle the eye with their unexpected brilliance."

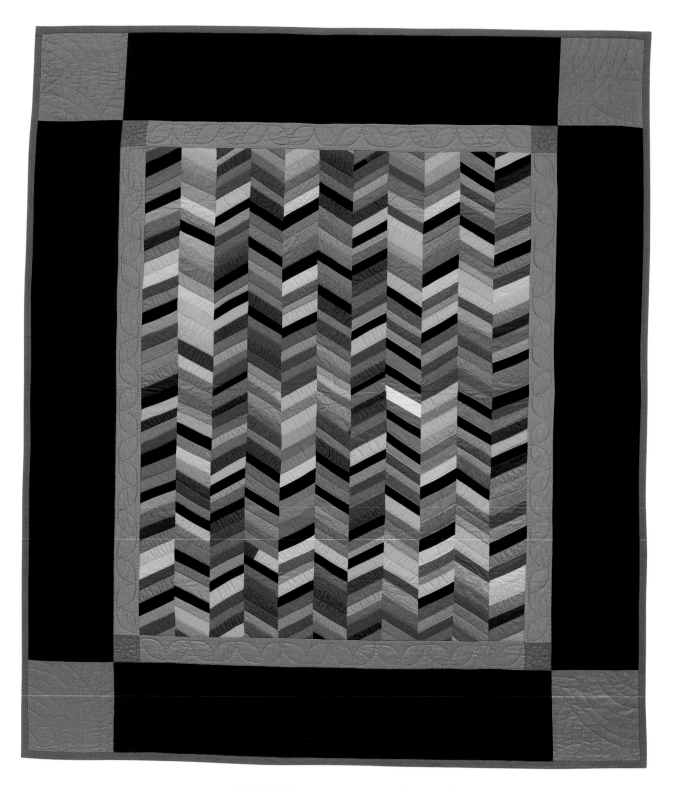

STRING-PIECED BARS 70" x 78" | 1989

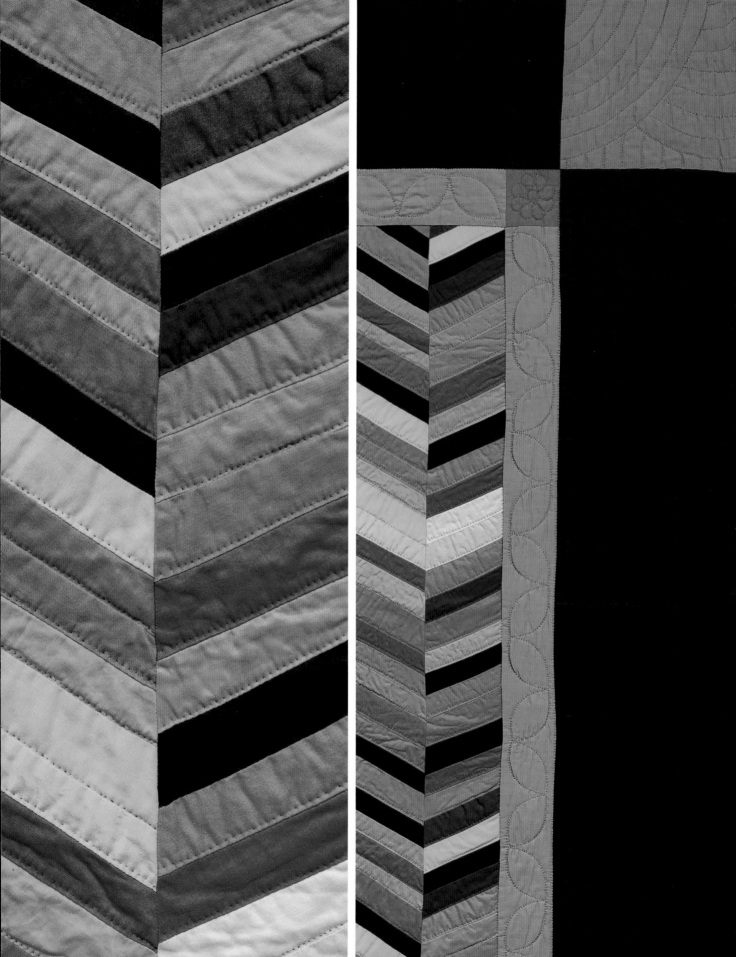

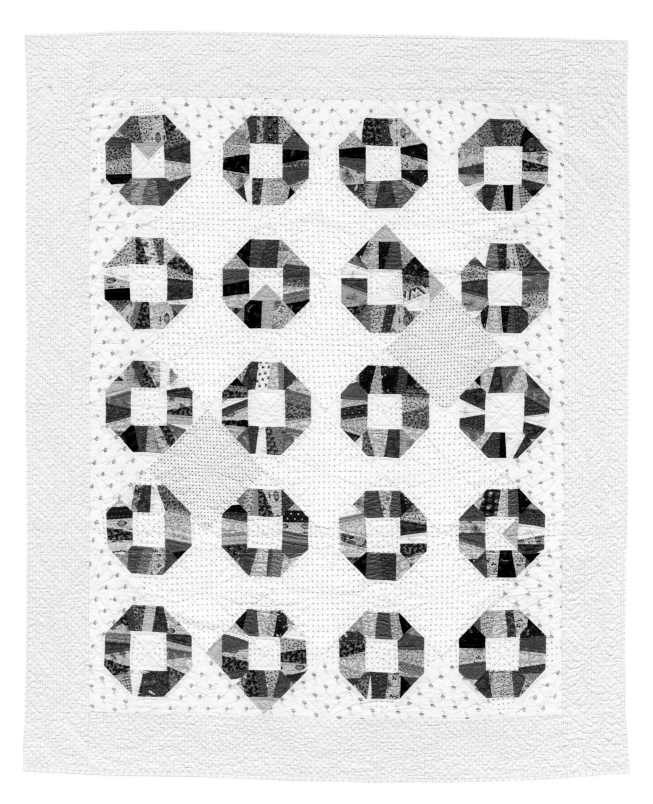

LIBERATED WEDDING RING 54" x 64" | 1999

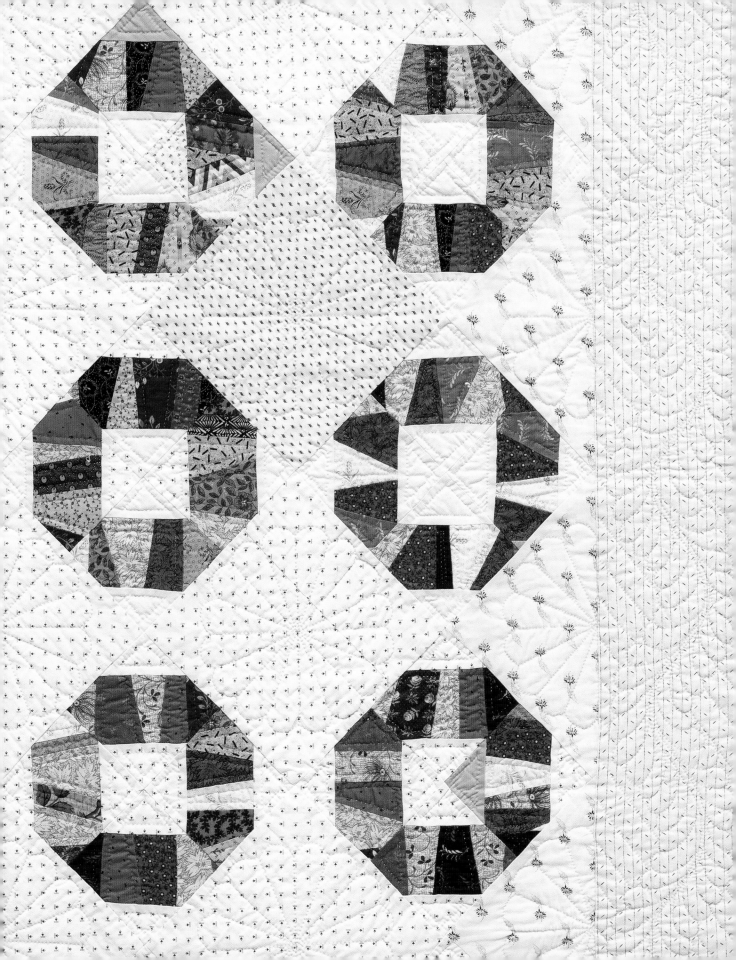

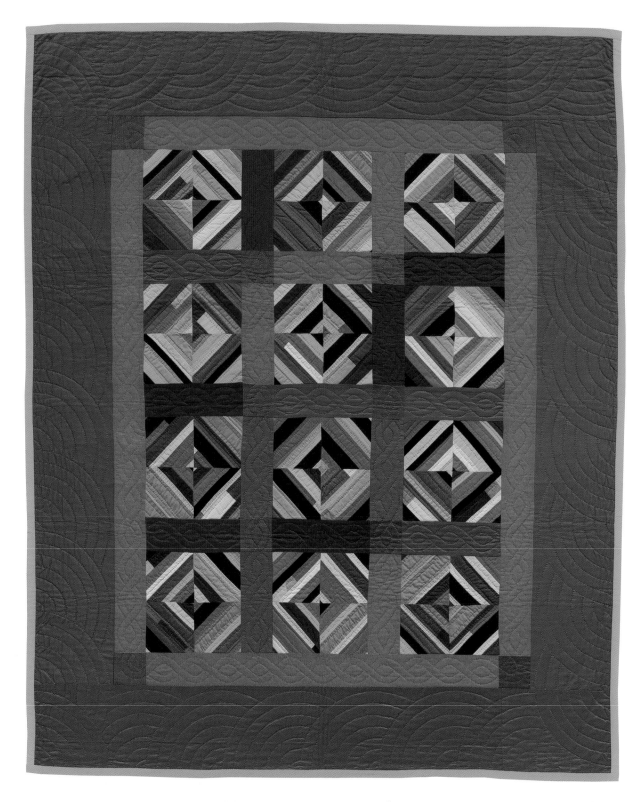

LIBERATED STRINGS 55" x 67" | 1999

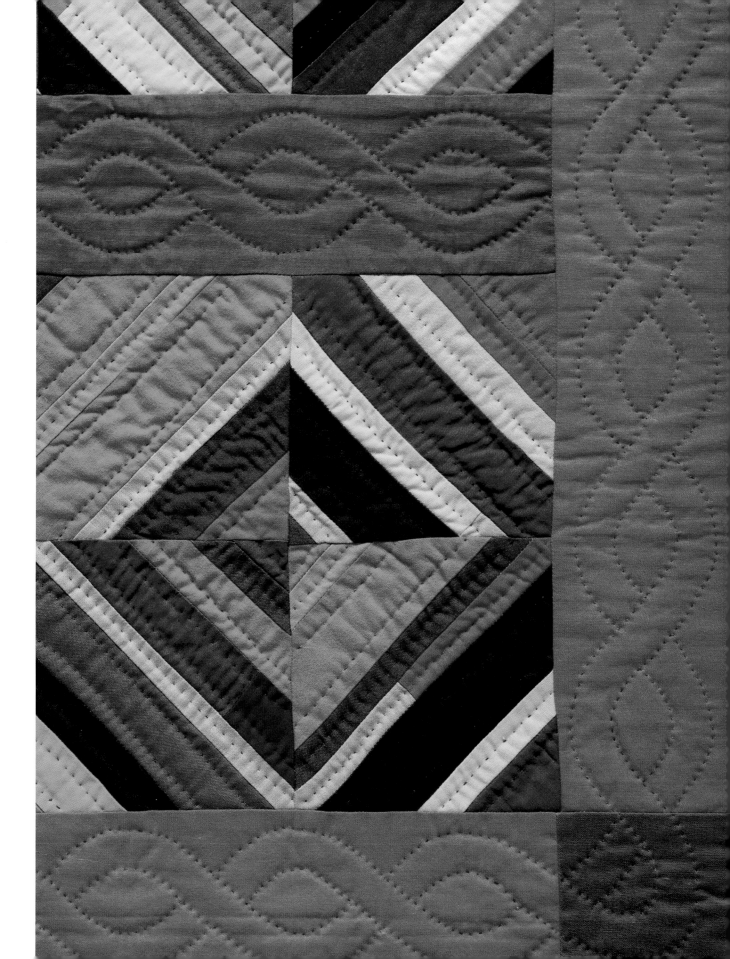

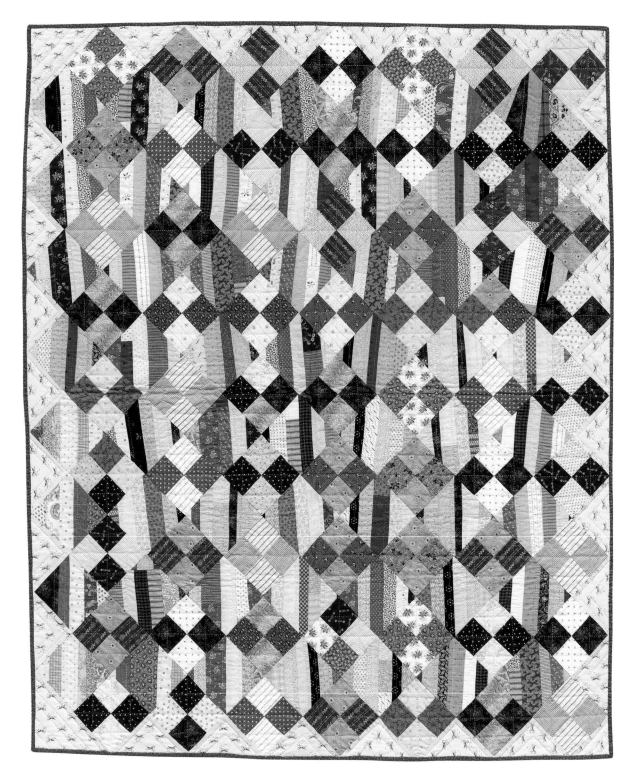

STRINGS AND FOUR PATCH 42" x 50" | 2001

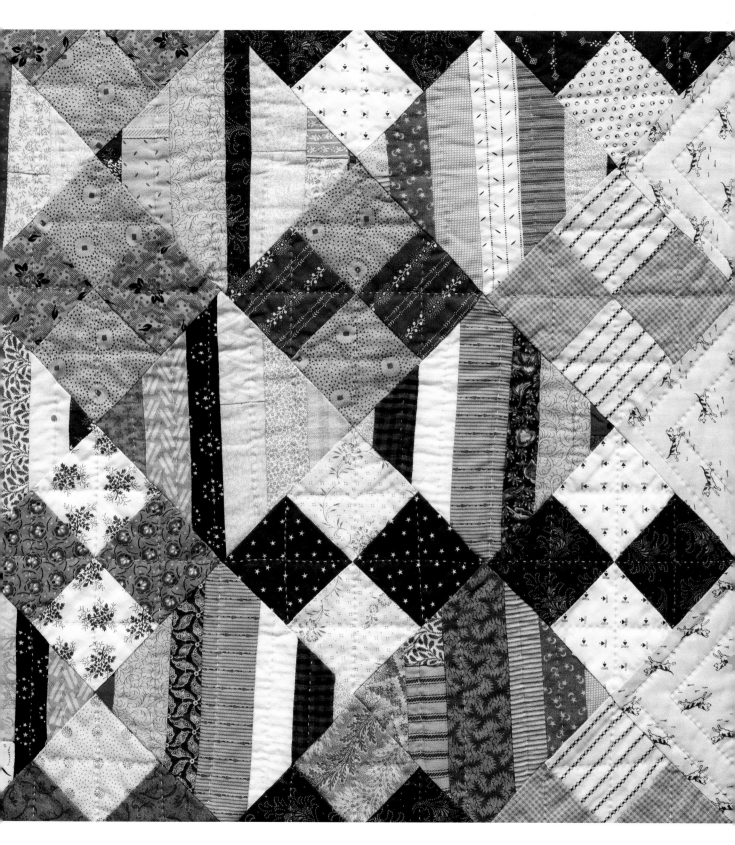

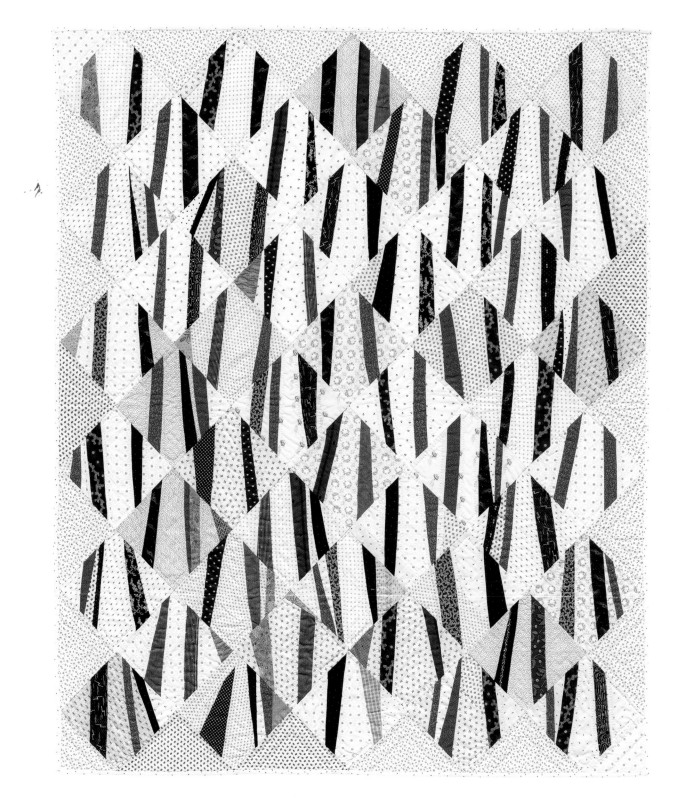

MINIMAL STRING 38" x 43" | 2009

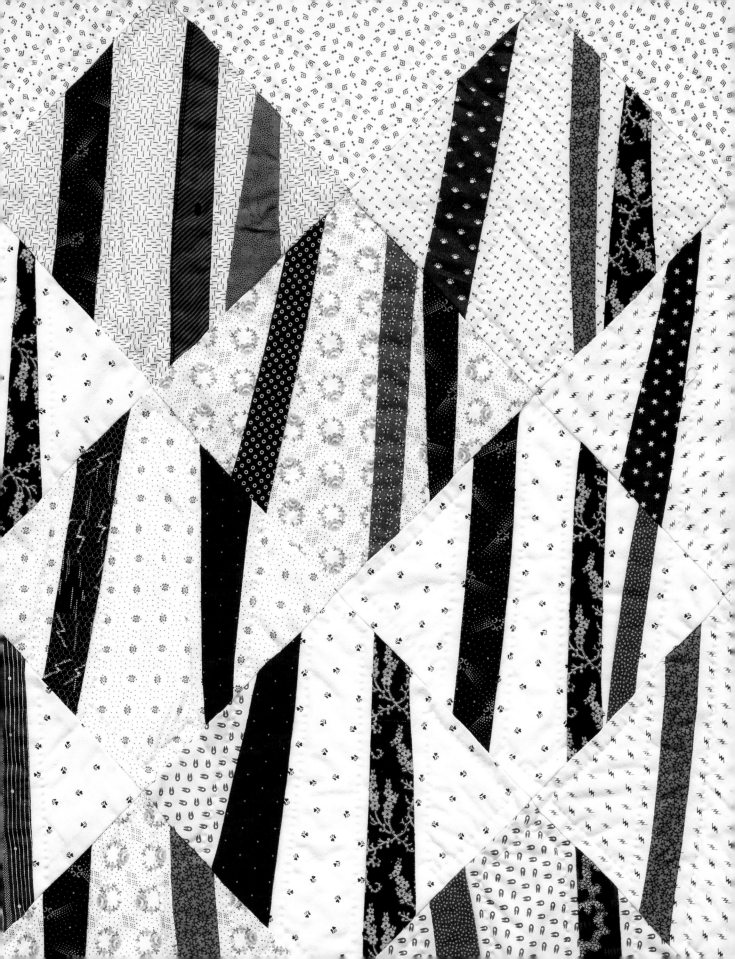

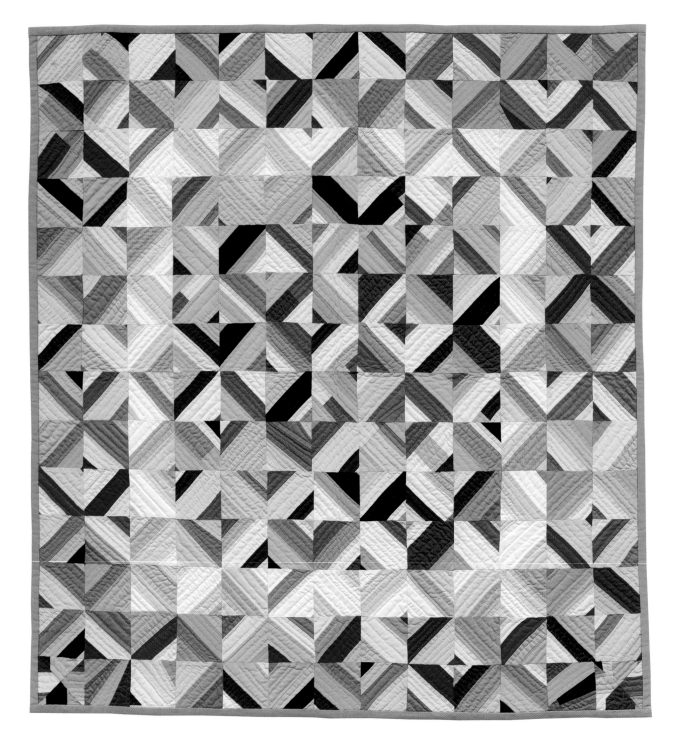

CLASSIC STRING MEDALLION 45" x 48½" | 2010

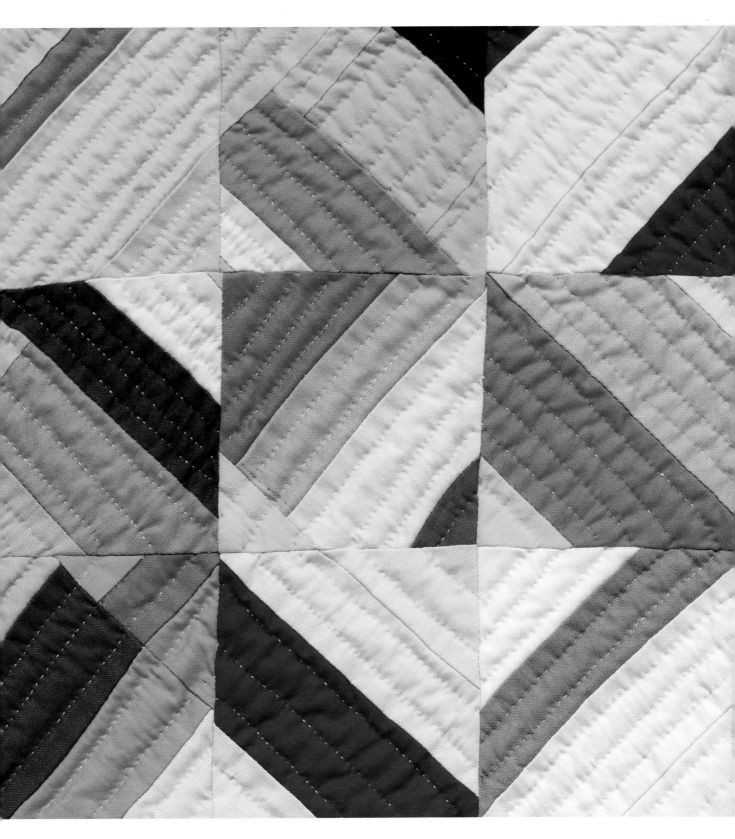

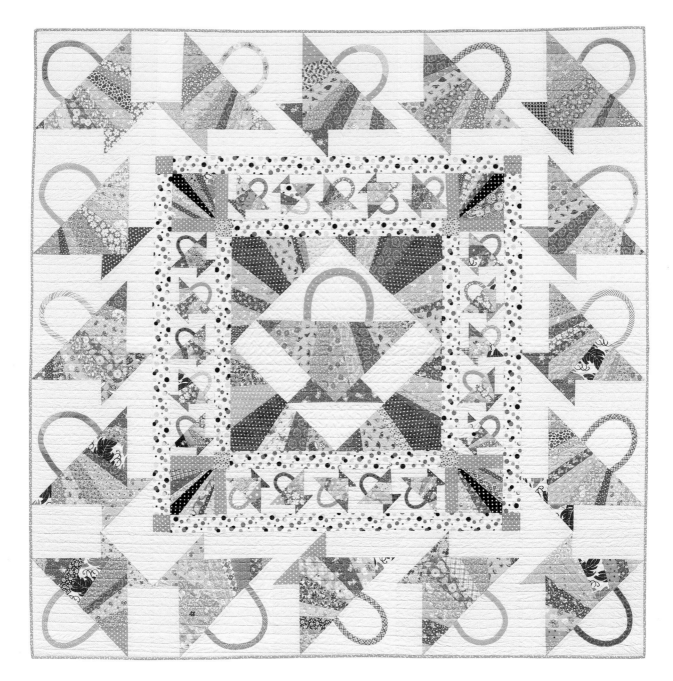

STRING BASKETS 70" x 70" | 2011

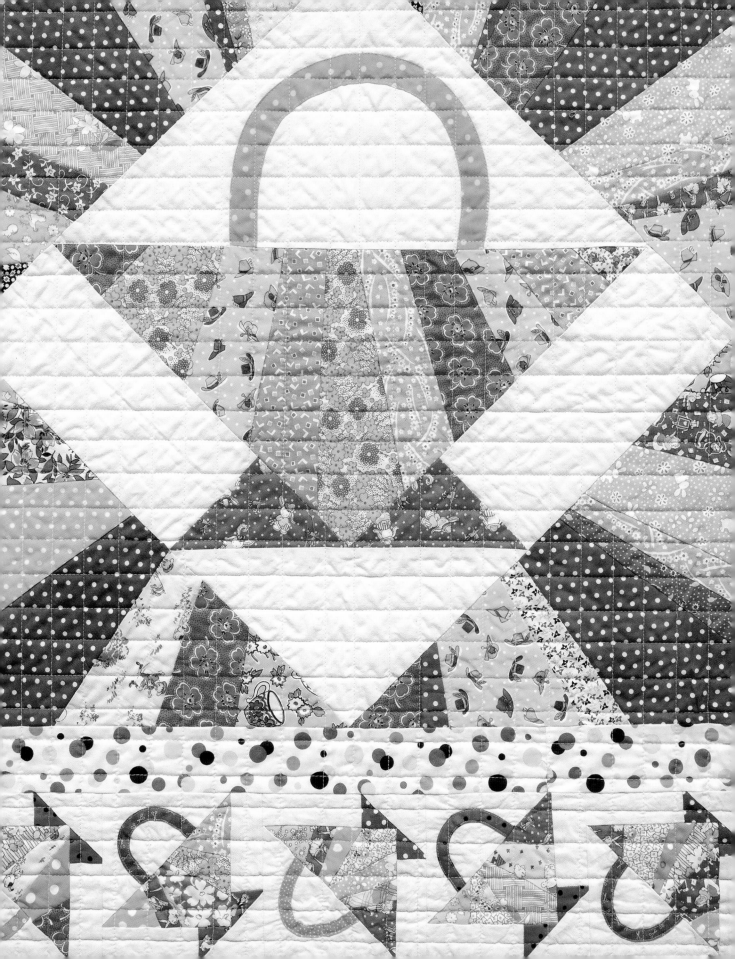

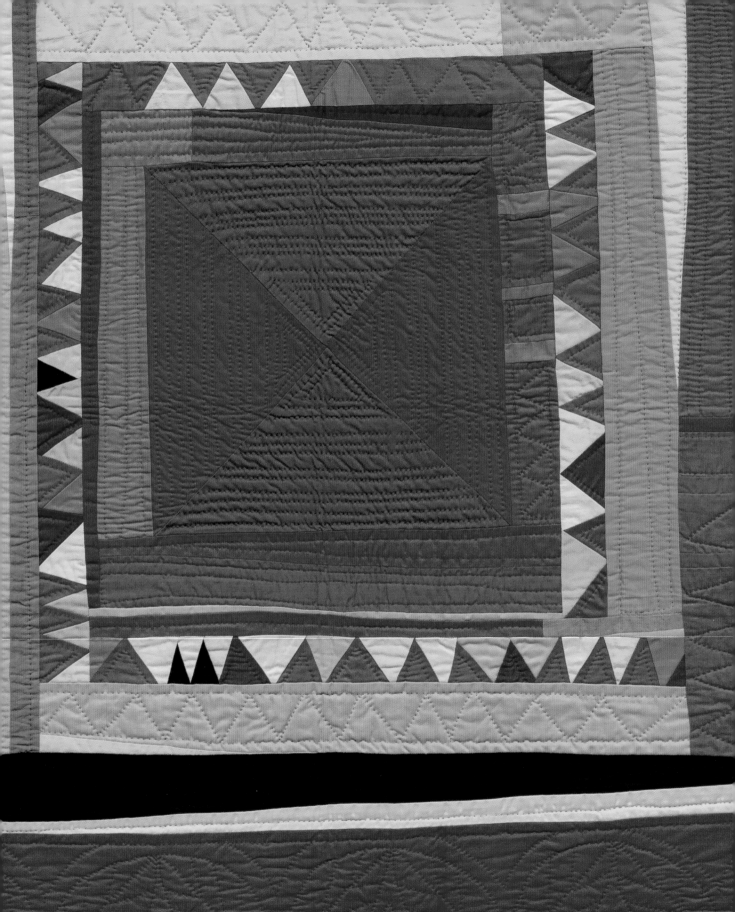

ABSTRACT QUILTS IN SOLIDS

Throughout my quilting life I have always enjoyed working in solid fabrics. They are definitely my preference when creating abstract quilts because they seem more "painterly" than prints, if for no other reason than paint itself comes in solid colors. Also line and form are more clearly defined when solids are used. Solids emphasize more clearly the delineation between shapes, whereas prints can blur the edges of adjoining shapes. And I like the fact that my quilting stitches show up better on solids.

I build most of my work around a single idea, having a preference for simple design and repeated shapes. I use slight color changes, subtle unexpected elements, and often some degree of irregularity. I sometimes work in a series, such as the quilts shown on pages 126–131 and the last 10 quilts in this section. It's a good way to explore an idea that intrigues me.

I like constructing work that is challenging, and while some of these compositions may appear easy, I think they are actually harder because when there is less, everything counts more. There is also something restful about work that is refined down to only a few elements and seemingly without pretense. I think of some of my minimal work as being similar to a haiku in that a minimal quilt and a haiku are both required to deliver the whole story in brief.

"My intention is to construct work that is sparse, unpretentious, and makes sense as a whole."

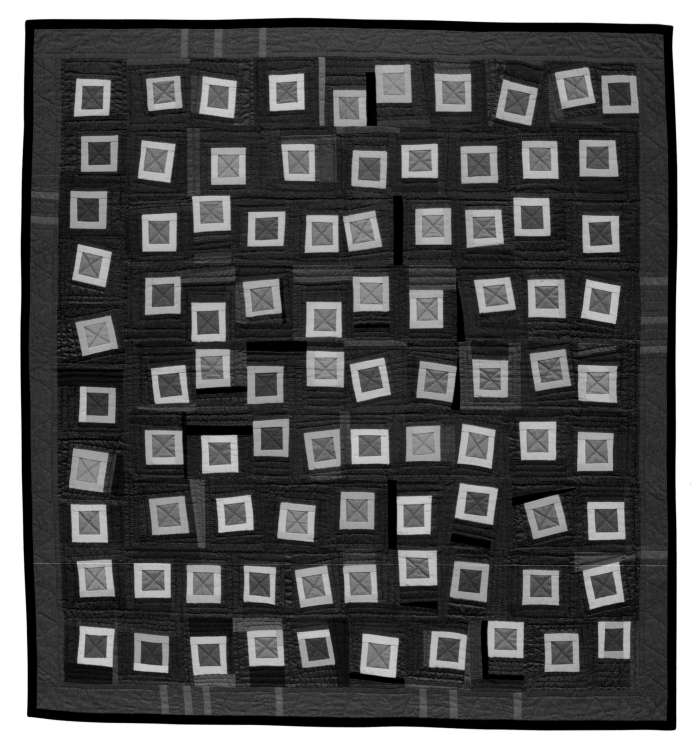

RED SQUARE III 43" x 45" | 2007

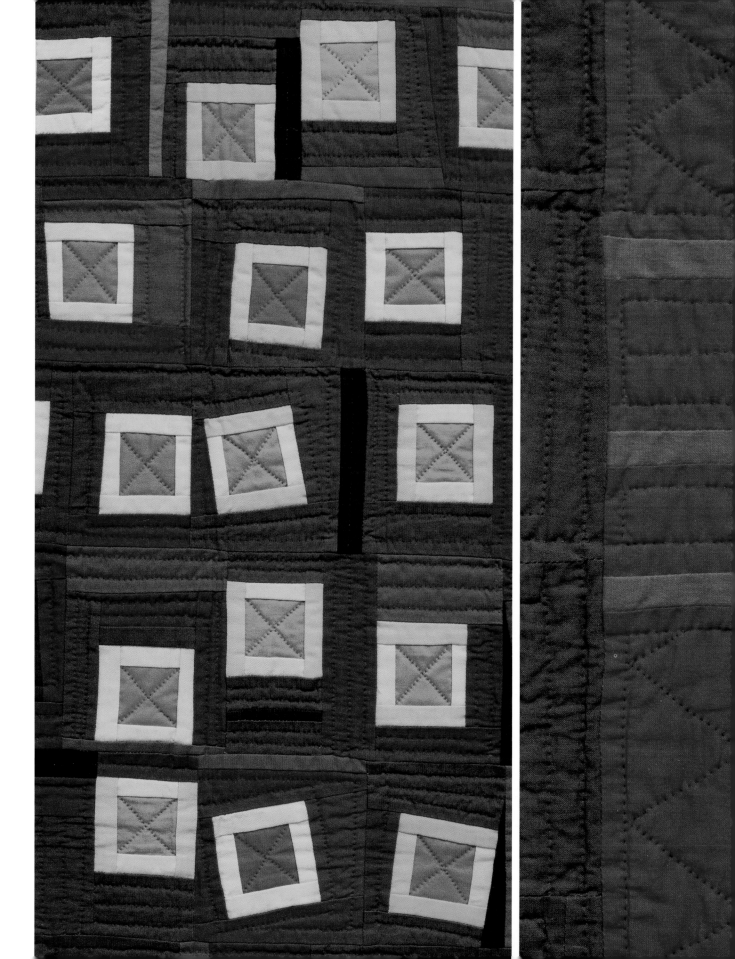

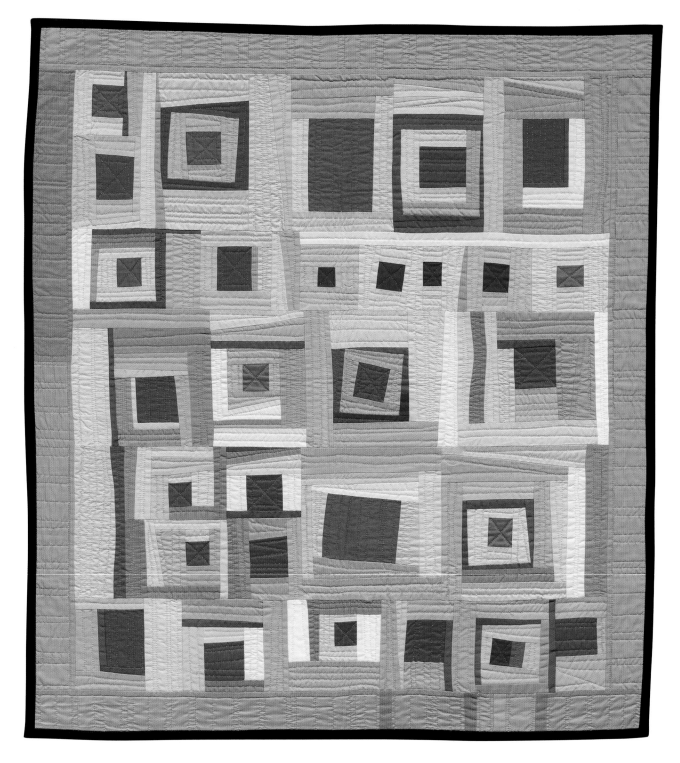

RED SQUARE IV 39" x 42" | 2008

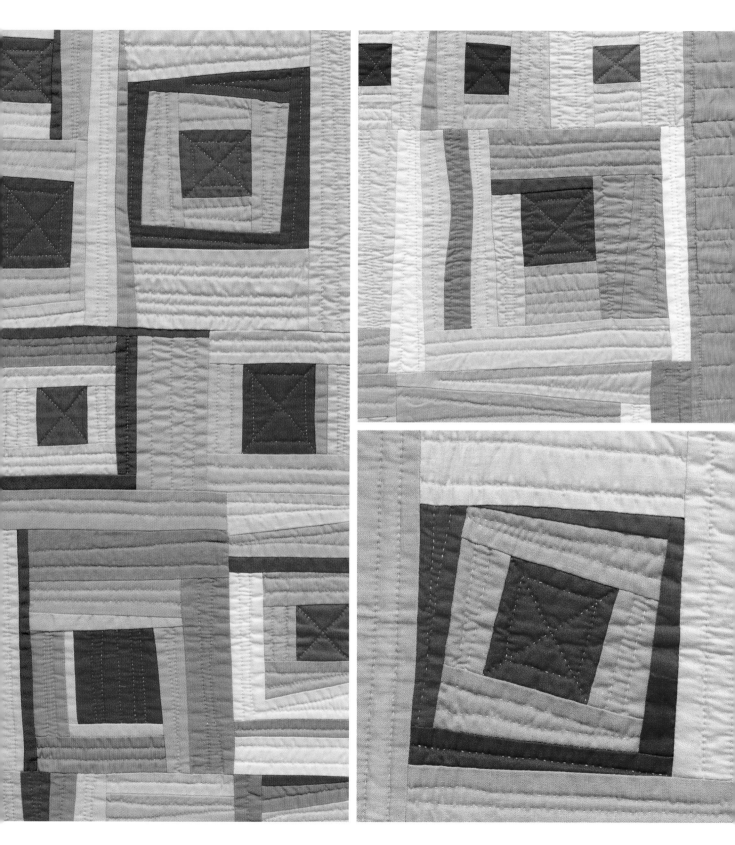

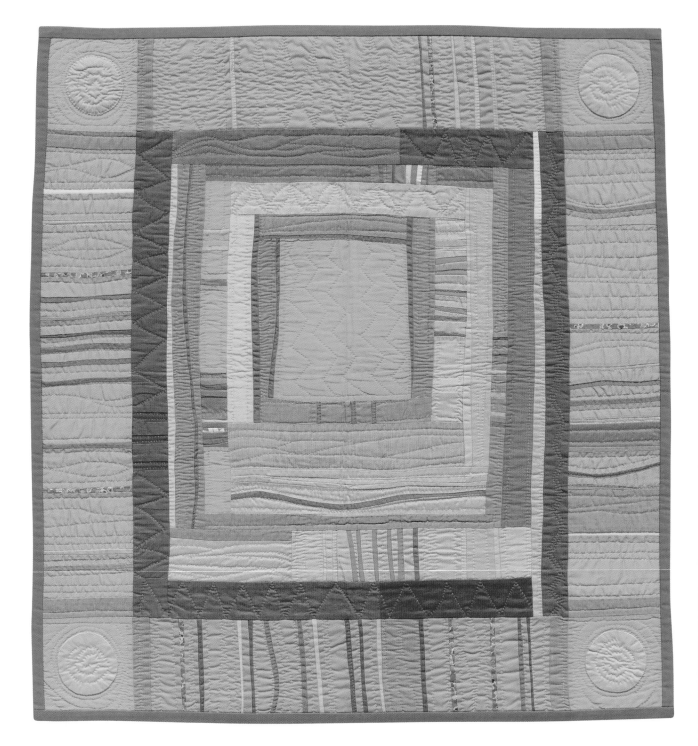

HIGH DESERT COUNTRY III 34" x 36" | 2008

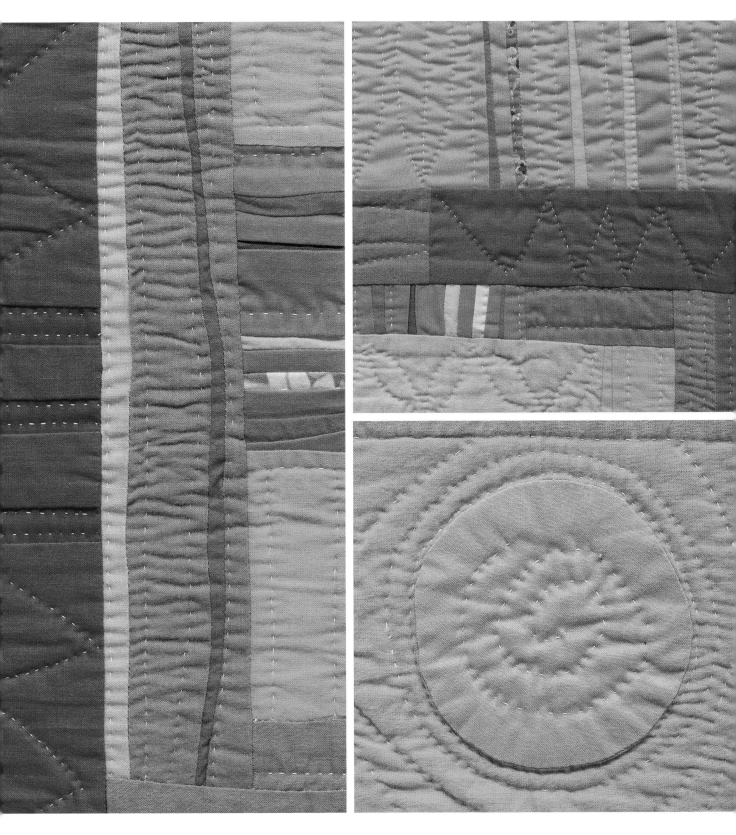

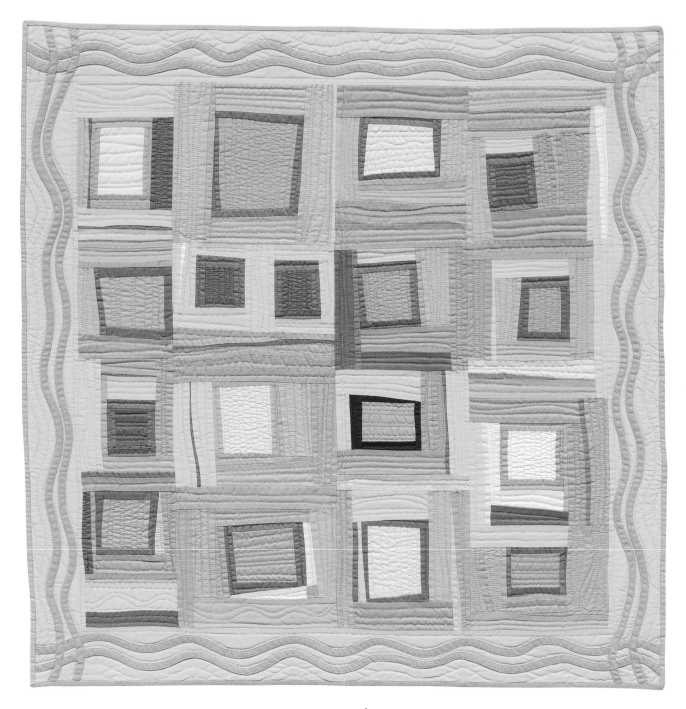

LIBERATED LOG CABIN WITH APPLIQUÉD BORDER 38" x 46" | 2008

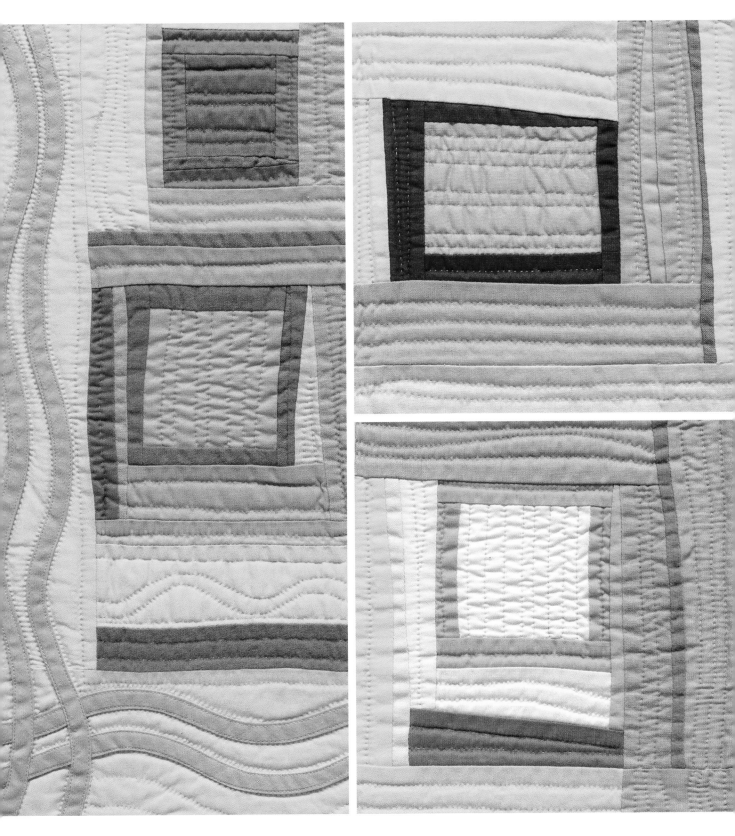

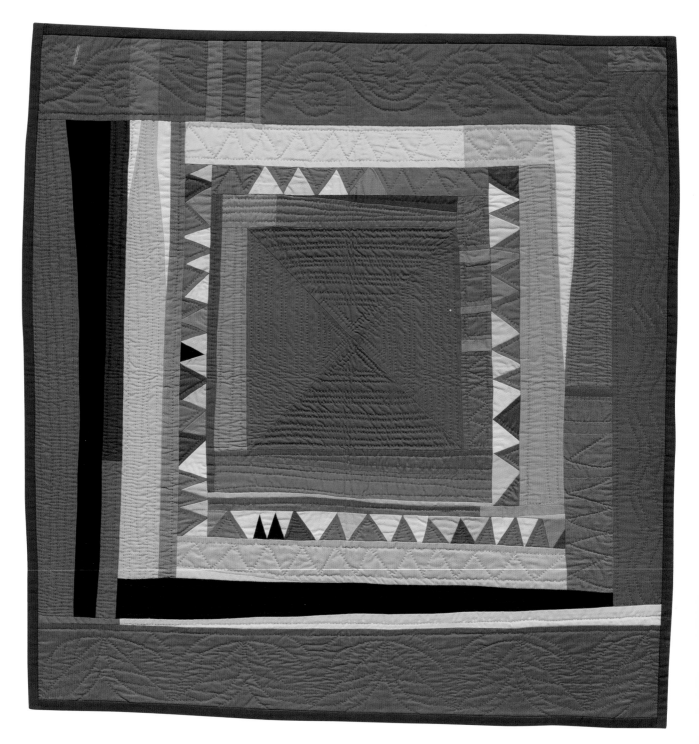

BROKEN DISHES 37" x 38" | 2008

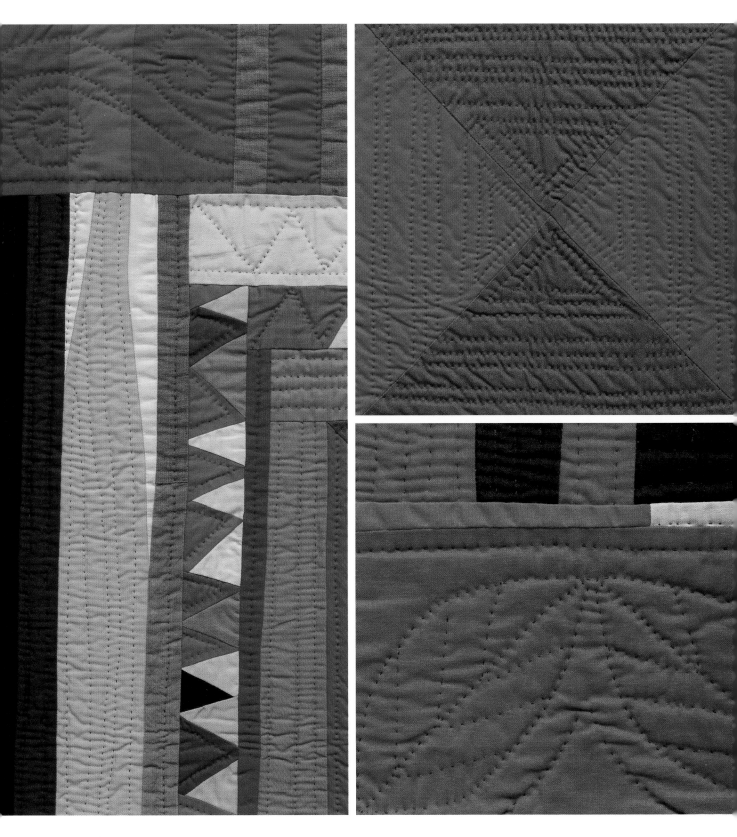

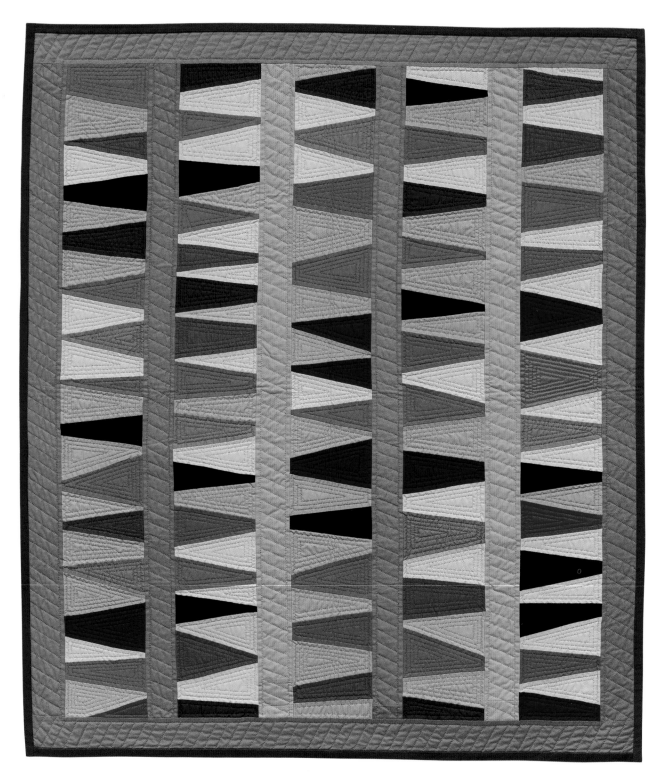

SAWTOOTH 43" x 49" | 2009

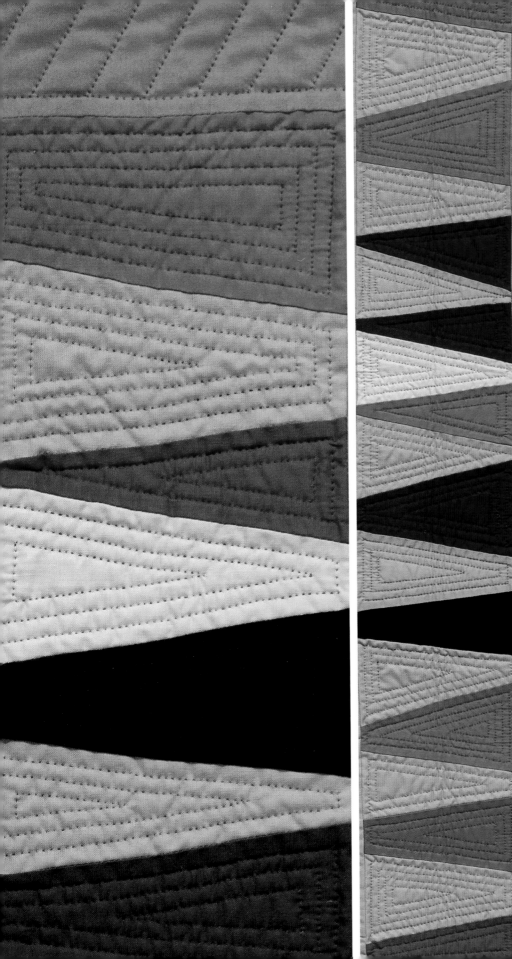
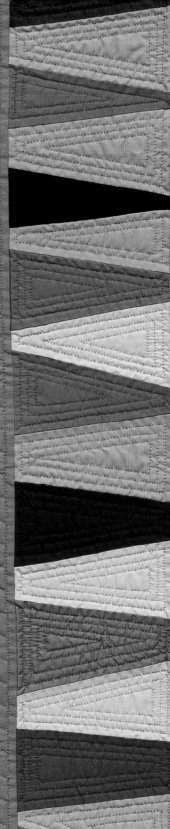

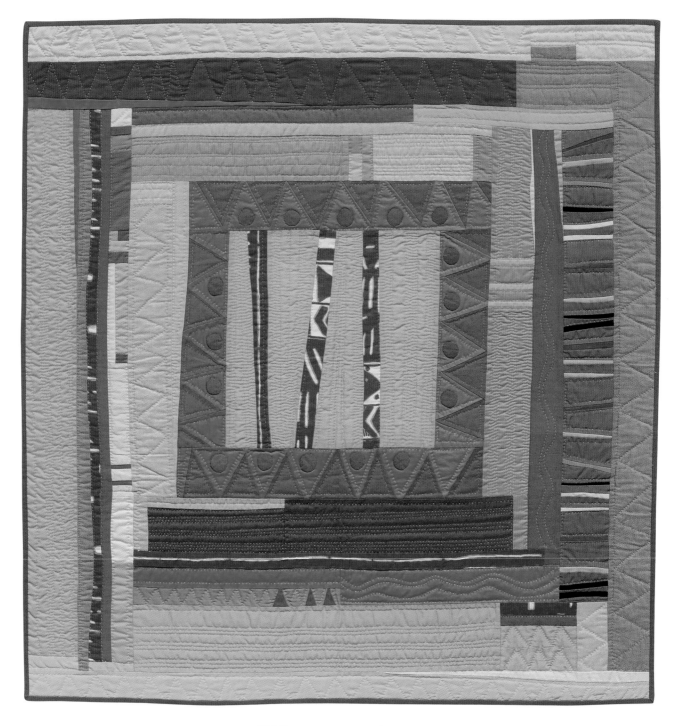

UNTITLED 35" x 36½" | 2009

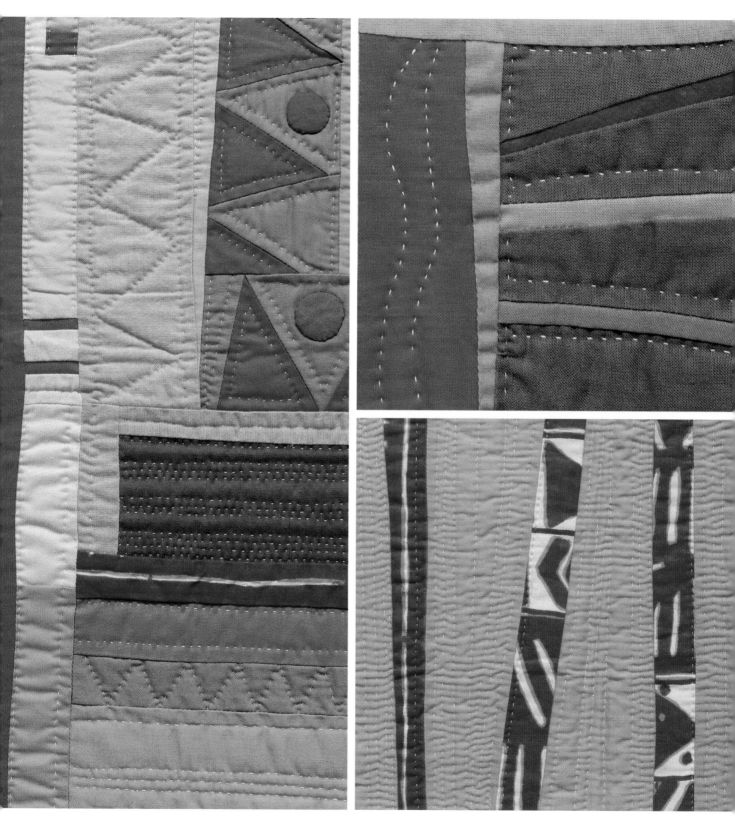

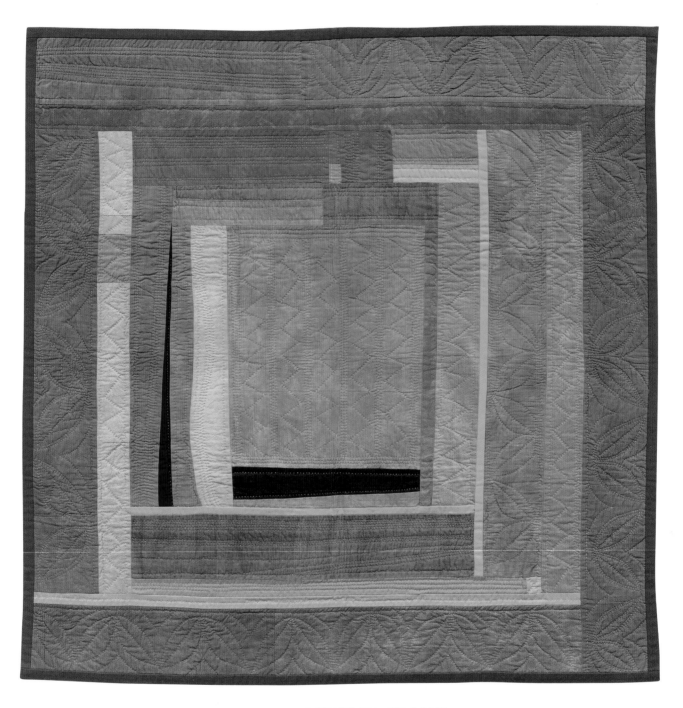

LIBERATED MEDALLION 37" x 37" | 2009

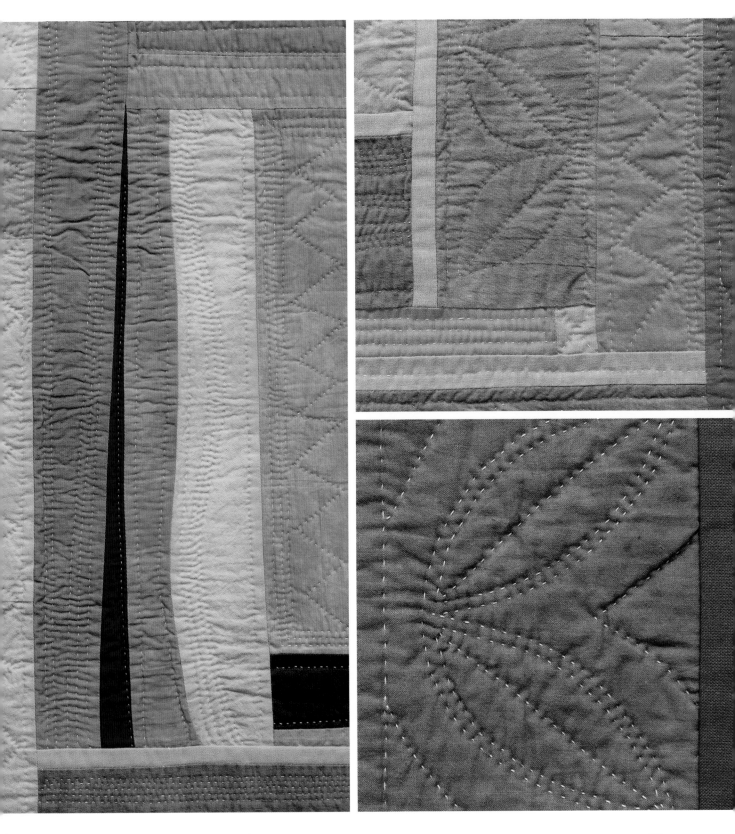

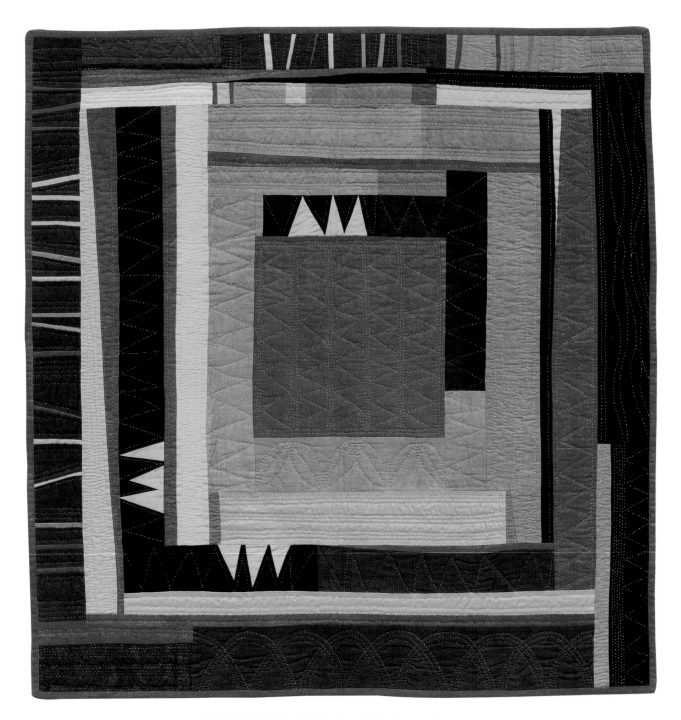

MEDALLION WITH THREE TRIANGLES 34" x 35" | 2010

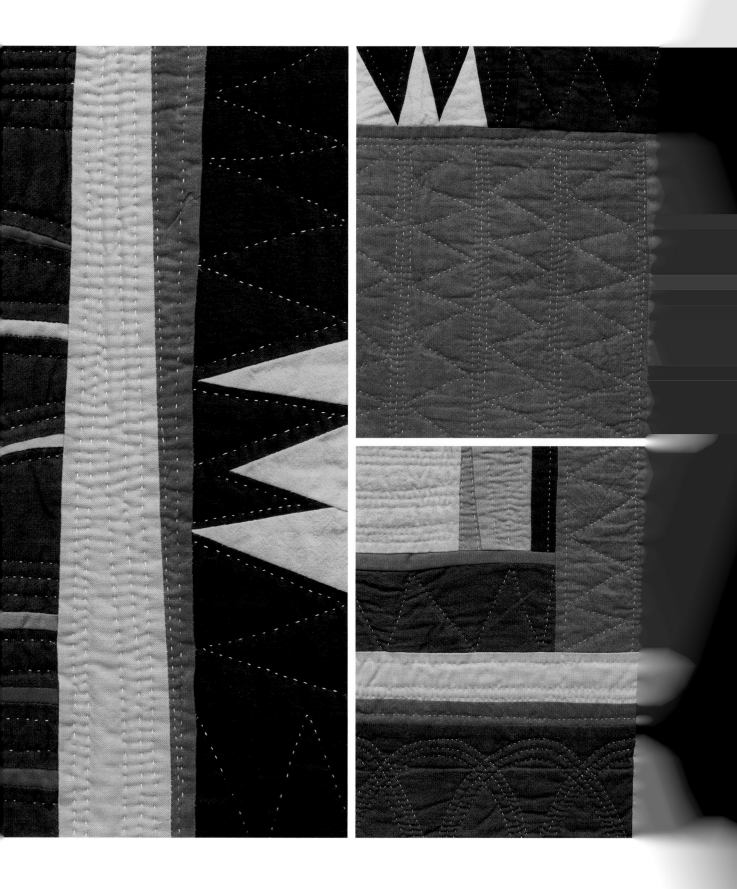

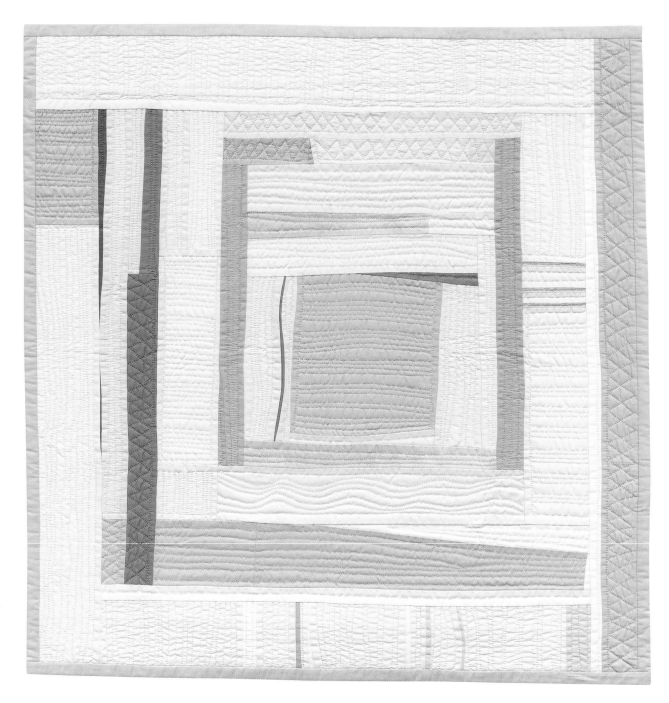

MEDALLION II 33" x 33" | 2010

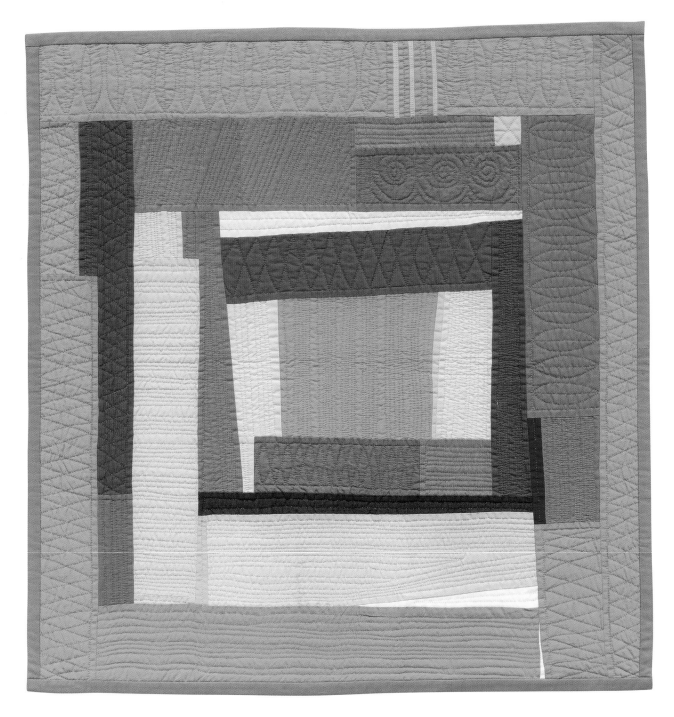

MEDALLION III 33" x 33" | 2010

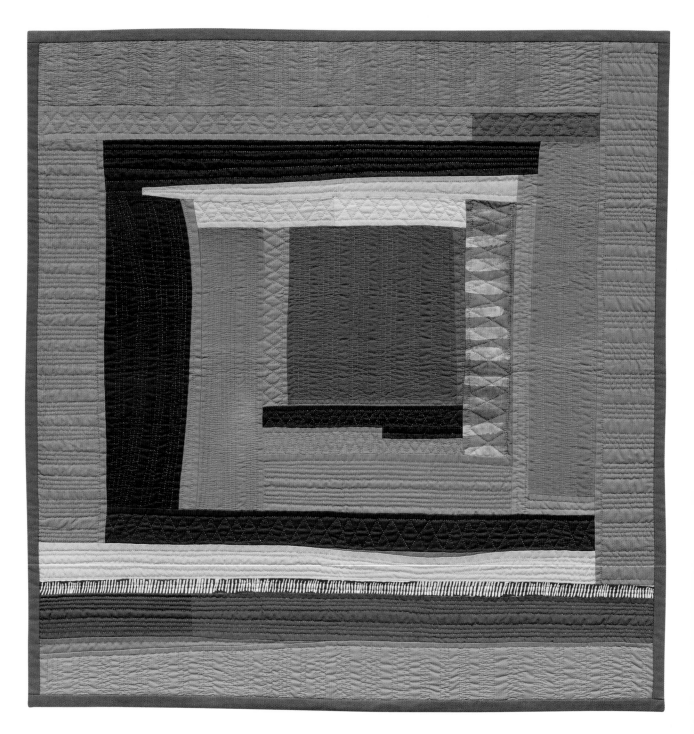

MEDALLION IV 33" x 33" | 2010

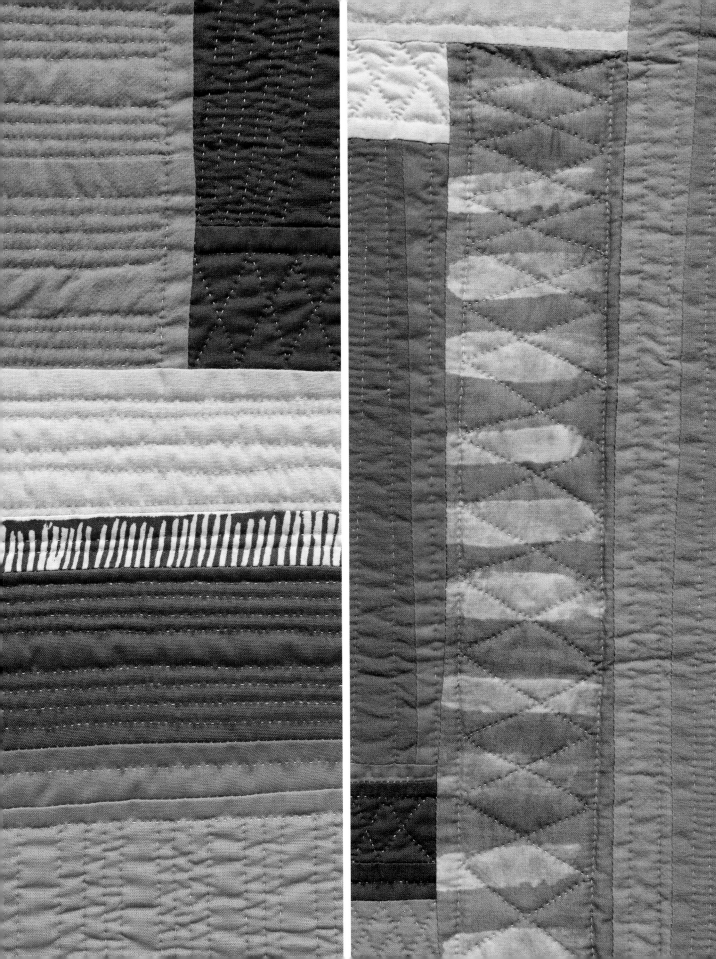

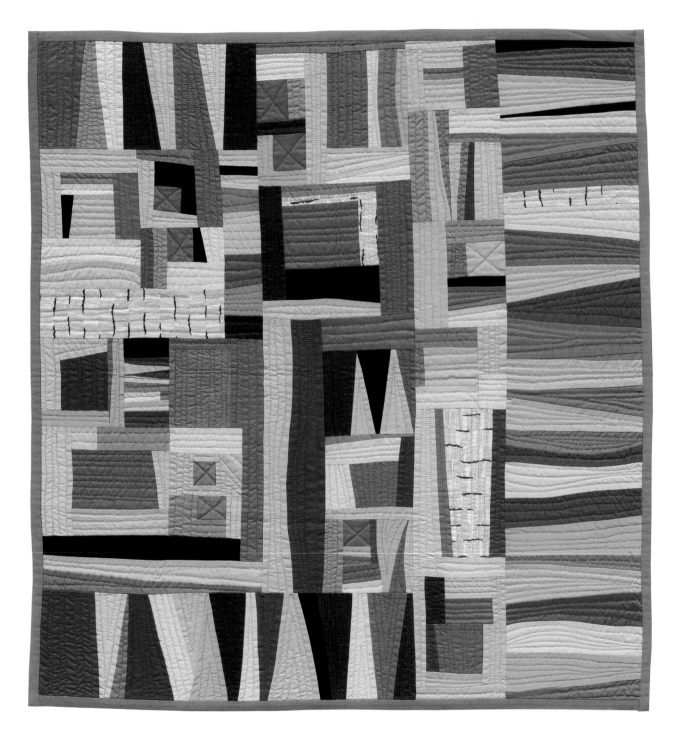

ABSTRACTION 36" x 38" | 2012

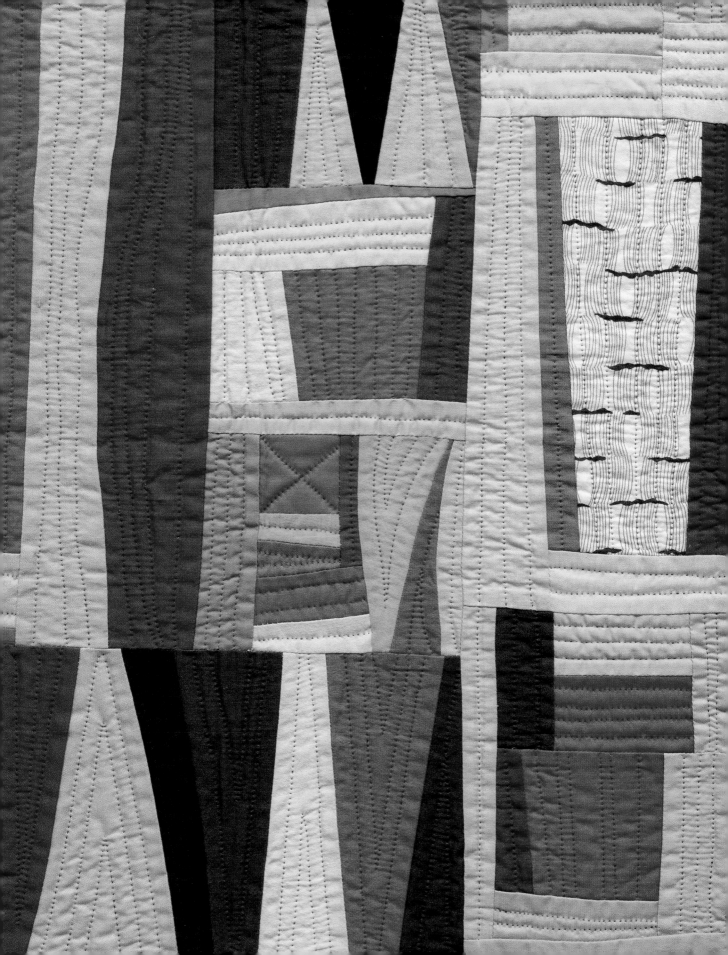

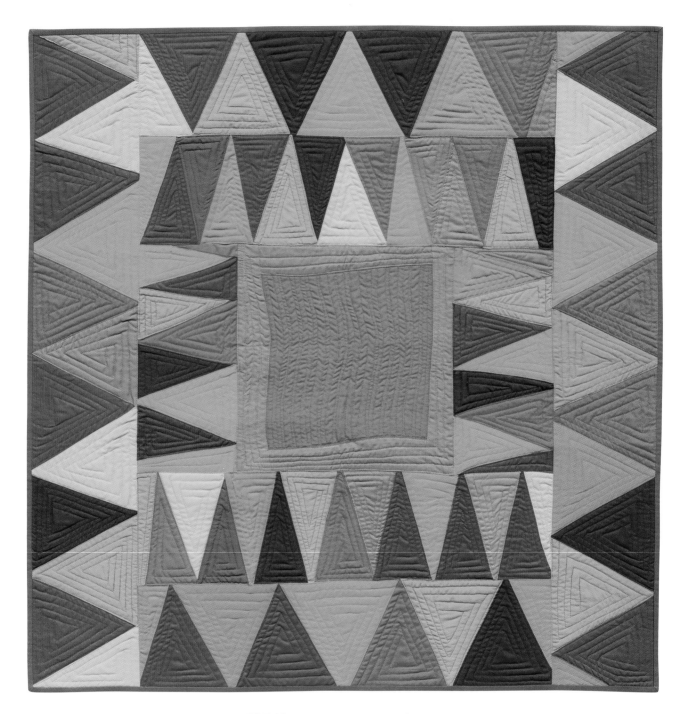

THE COURT JESTER 34" x 34" | 2015

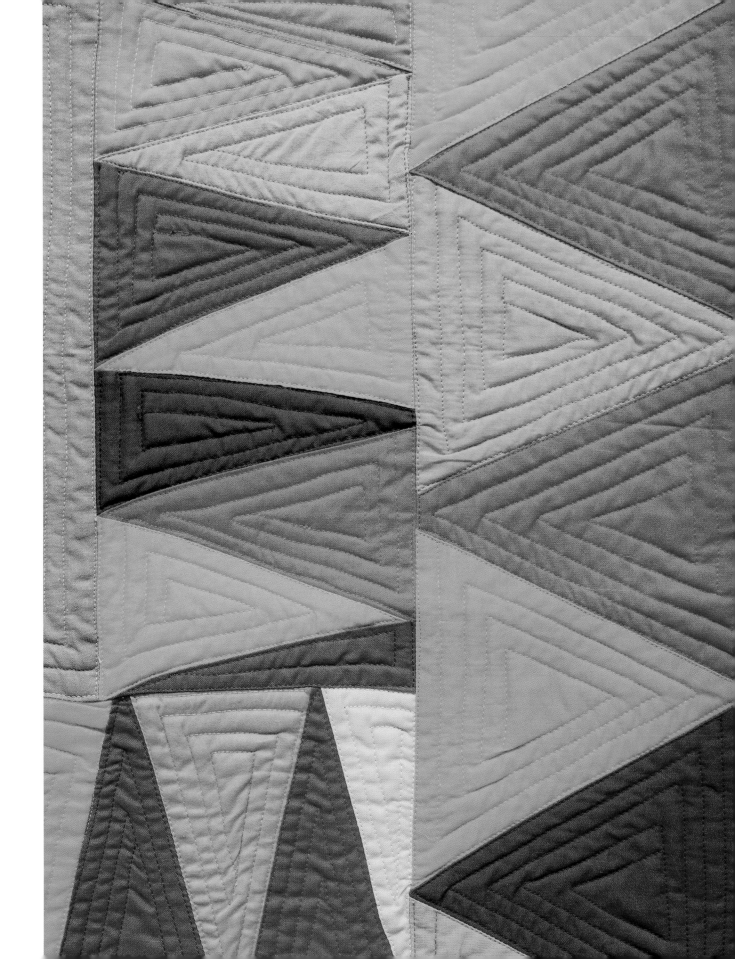

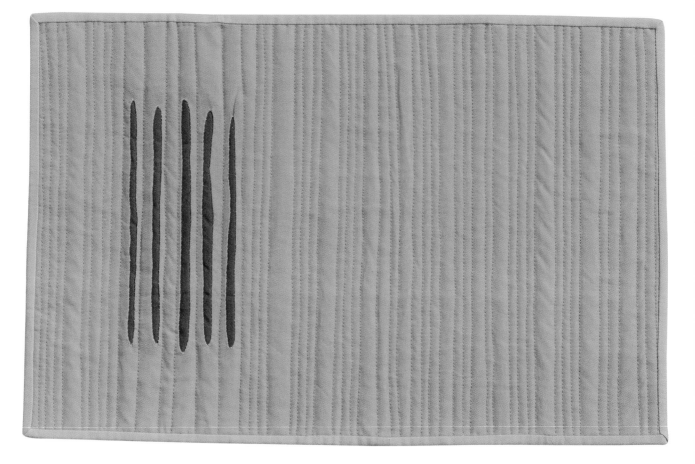

THE FINGER LAKES 17½" x 11½" | 2015

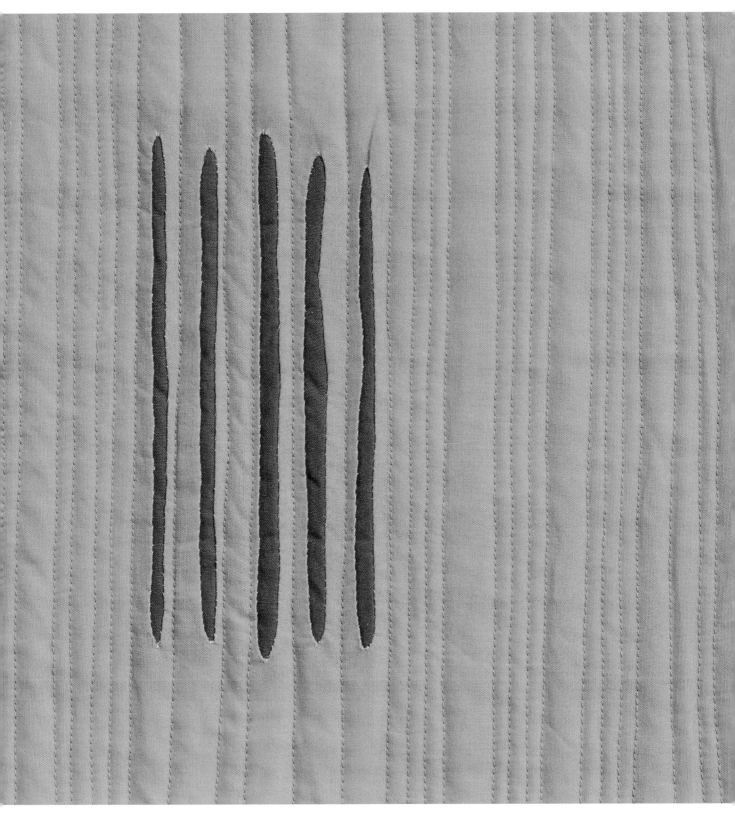

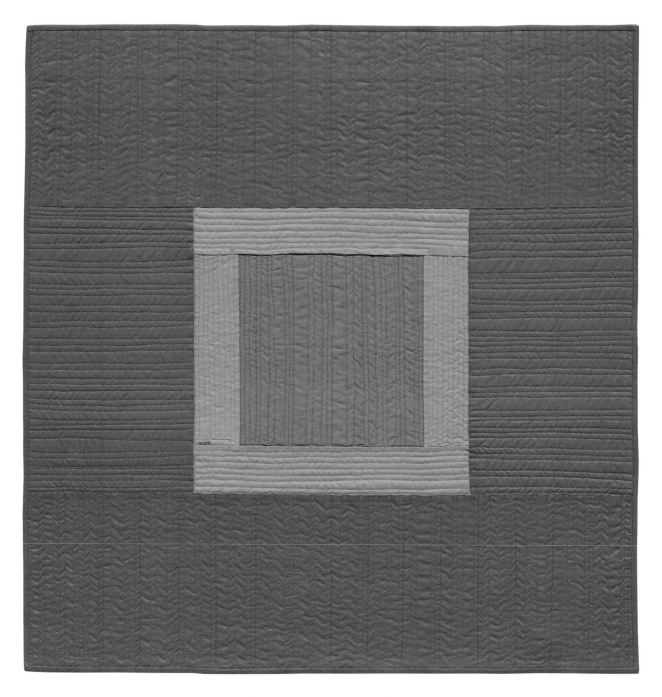

COLOR STUDY 1 33" x 33" | 2015

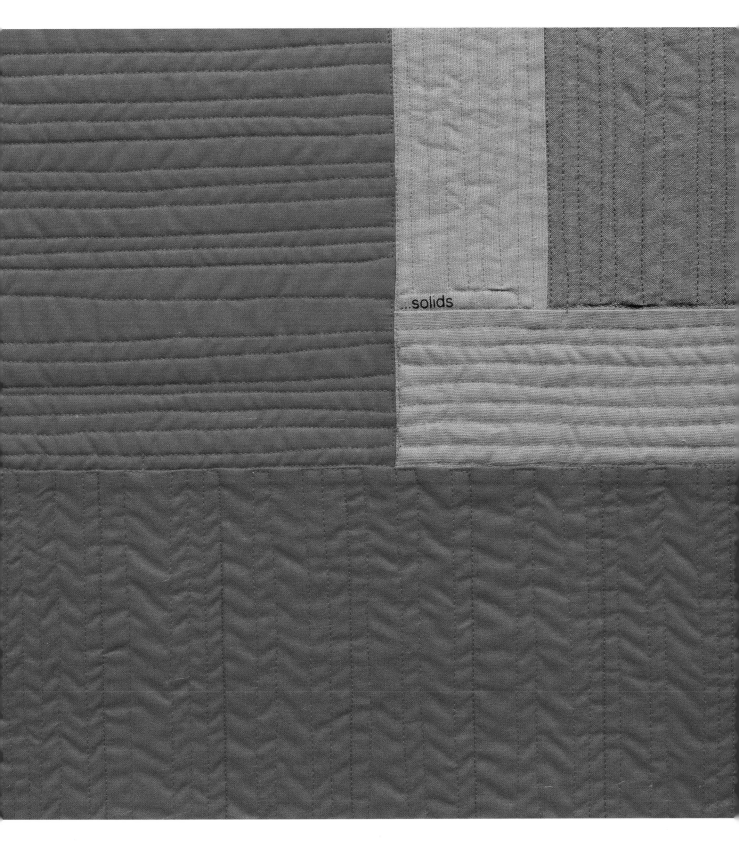

...solids

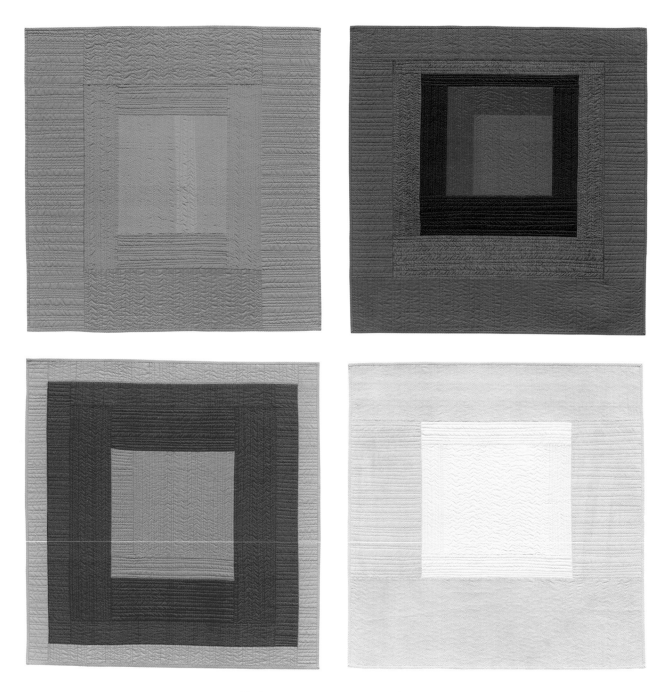

COLOR STUDIES 2–5 33" x 33" | 2015

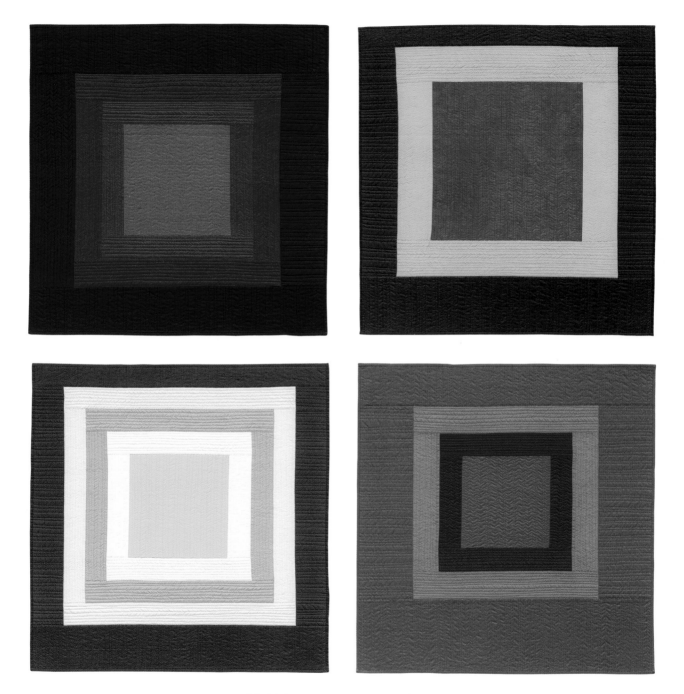

COLOR STUDIES 6-9 33" x 33" | 2015

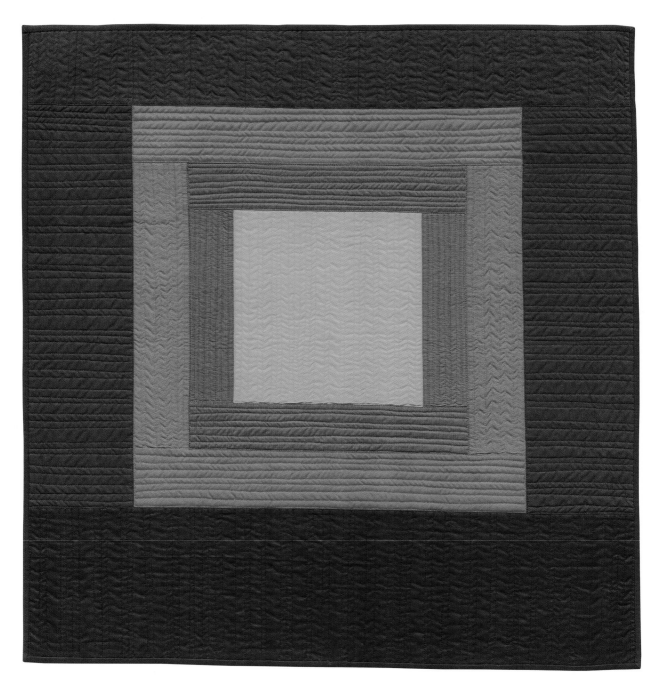

COLOR STUDY 10 33" x 33" | 2015

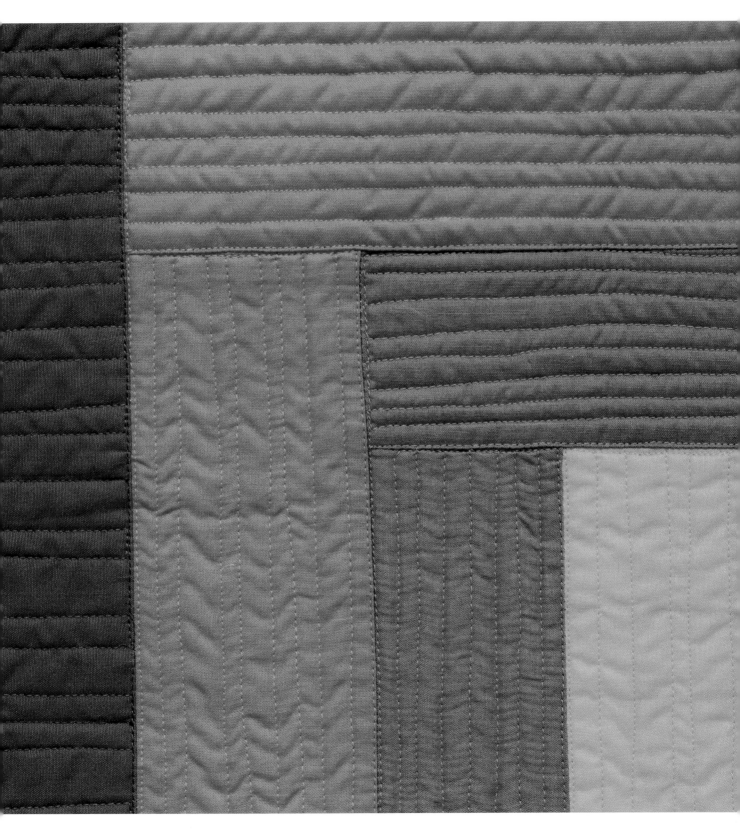

ABOUT GWEN MARSTON

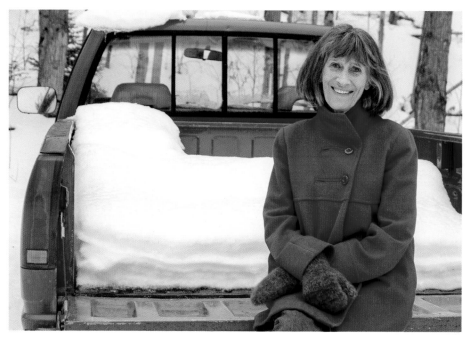

Photo by Frank Solle

If you haven't met Gwen Marston, the first thing you need to know is she's a great artist with a wonderful sense of humor. She's also a pioneer in the world of quilts, but she's very down-to-earth despite all her success. She draws inspiration from old quilts but doesn't really reproduce them. Everything she does is absolutely her own creation.

~ Bill Volckening

Those are the words of Bill Volckening, award-winning photographer, blogger, quiltmaker, and quilt collector. His words couldn't be more true.

In this, her 30th published book, Gwen Marston is sharing for the first time a retrospective of her 40-year passion for quilt study, creativity, innovation, and inspiration.